UP NORTH

Reflections Moments & Memories

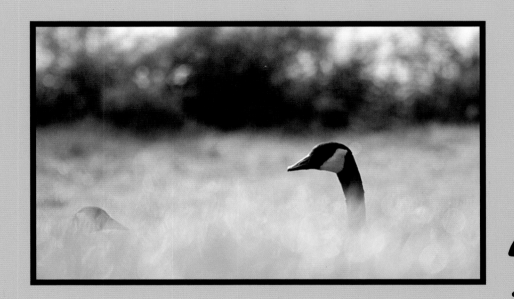

JOE BRANDMEIER

TRISTAN PUBLISHING
MINNEAPOLIS

Amy & Zach
Peace
Find up
Brandmeier

To John Muir, "The Father of the National Parks". To
Nature and all it's beauty, power and peace. To my crazy
brothers & sister. To my family who've shared my passion.
To Frank (my dad) & Hanky (my mom).

Thanks to all of you!
Joey

Library of Congress Cataloging-in-Publication Data

Brandmeier, Joe.
Up north / by Joe Brandmeier.
p. cm.
ISBN 978-0-931674-60-0 (alk. paper)
1. Nature photography. 2. Nature--Quotations, maxims, etc. I. Title.
TR721.B752 2011
779'.3--dc22

2010052394

TRISTAN PUBLISHING, INC.
2355 Louisiana Avenue North
Golden Valley, MN 55427

Copyright © 2011, Joe Brandmeier
ISBN 978-0-931674-60-0
Printed in China
First Printing

Please visit www.TRISTANpublishing.com

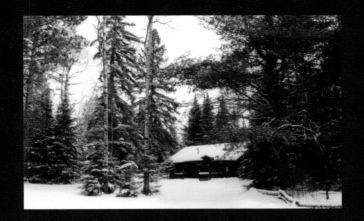

Introduction

Up North, to me, is a state of mind, an escape from reality. It's a place loaded with memories, solitude, romance, laughter, and craziness. My passion for Up North started when I was a kid, in my Grandpa's tiny log cabin, tucked away in the middle of Nicolet National Forest, in northern Wisconsin.

The pictures I've taken over the years are what keep me Up North. . . and it's important to me that you know what I saw through the lens is what you see on these pages. The pictures are pure — and the moments are real.

Wherever your Up North is, I hope it's a place of peace, where time can stand still, and your soul is truly free.

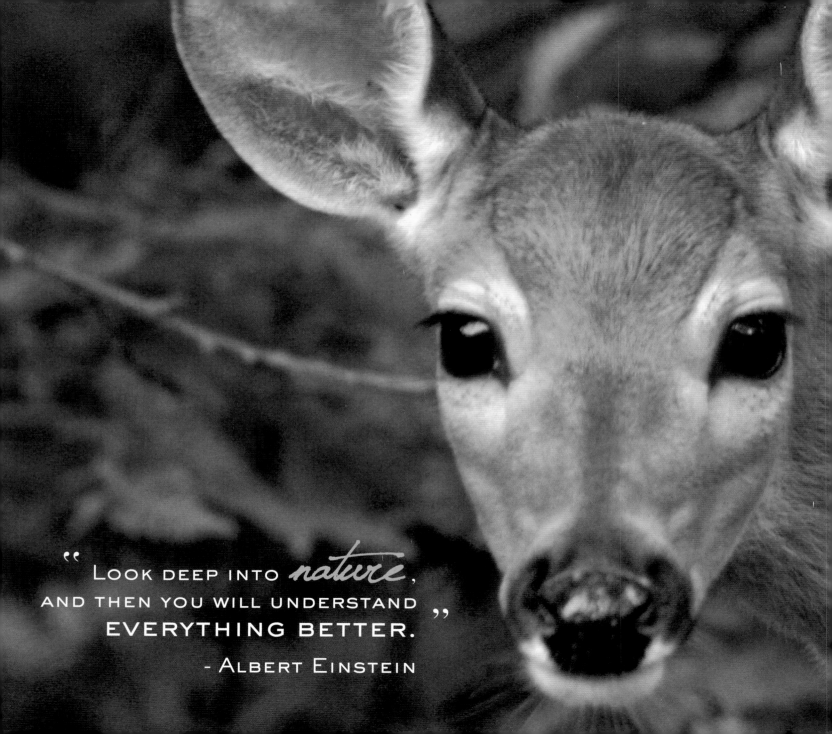

" Look deep into *nature*, and then you will understand everything better. "

- Albert Einstein

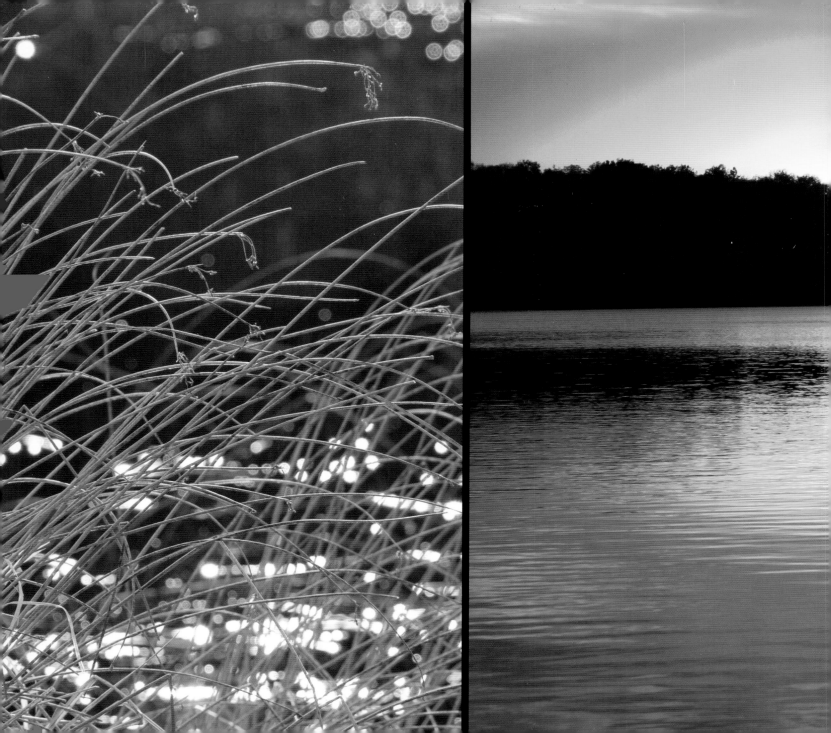

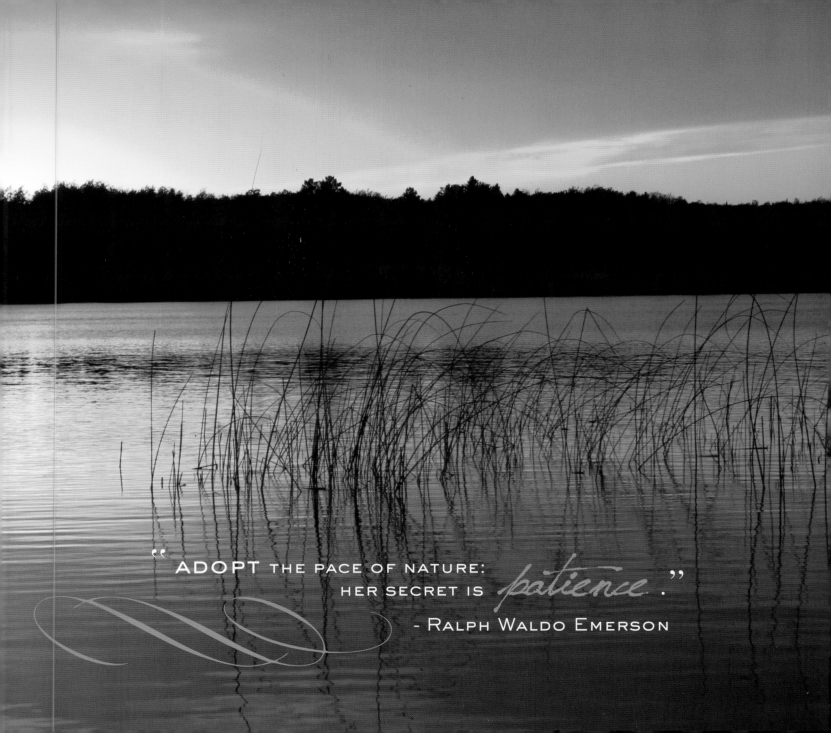

" ADOPT THE PACE OF NATURE: HER SECRET IS *patience* . "

— RALPH WALDO EMERSON

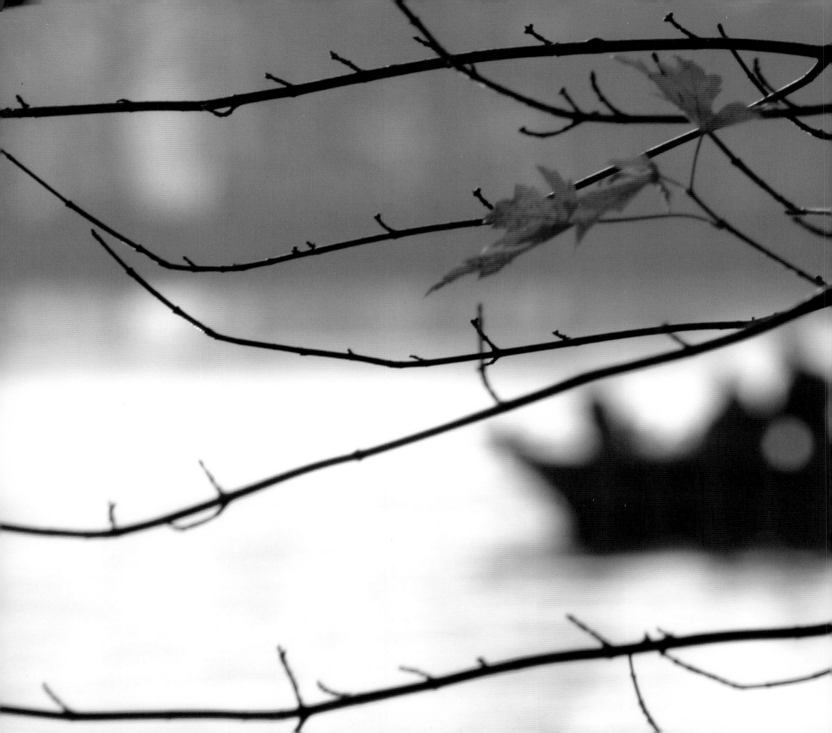

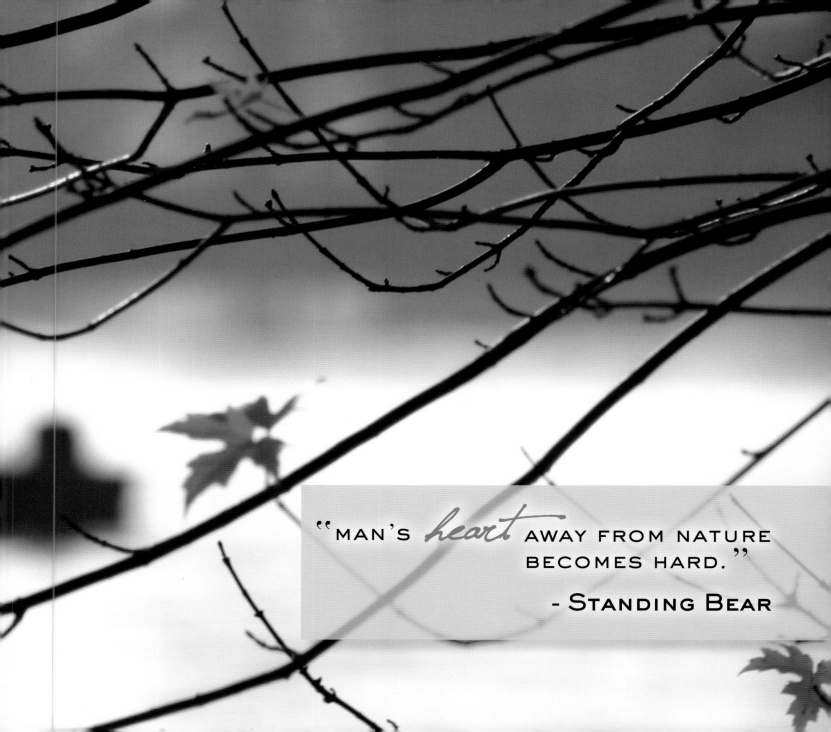

"MAN'S *heart* AWAY FROM NATURE
BECOMES HARD."

- STANDING BEAR

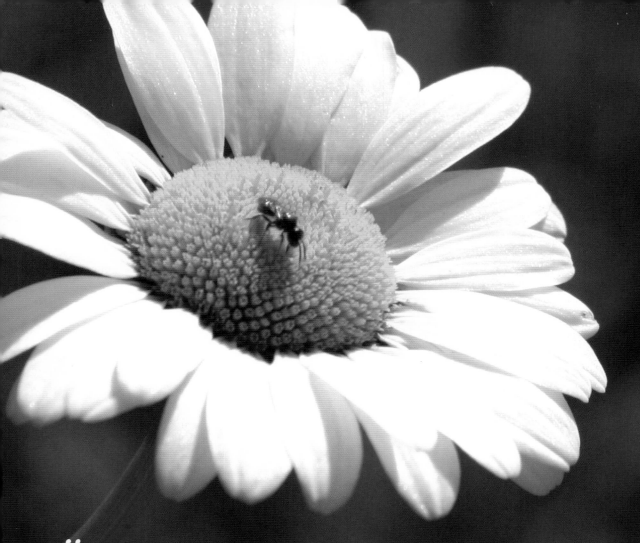

"WHEN ONE TUGS AT A *single thing* IN NATURE,
HE FINDS IT ATTACHED TO
THE REST OF THE **WORLD**. "

- JOHN MUIR

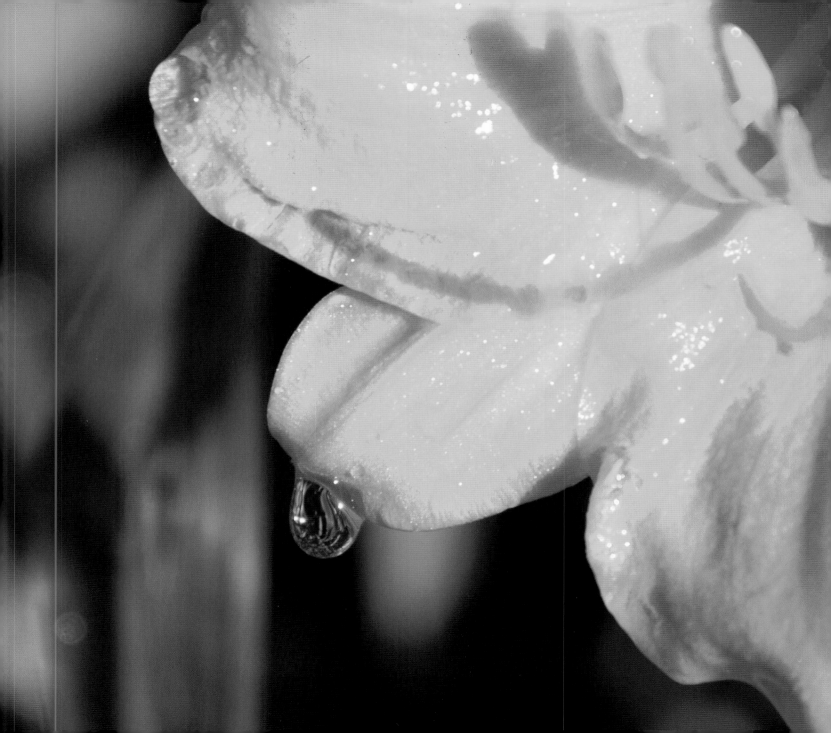

"I GO TO NATURE TO BE
SOOTHED AND HEALED,
AND TO HAVE MY
SENSES PUT IN ORDER."

- JOHN BURROUGHS

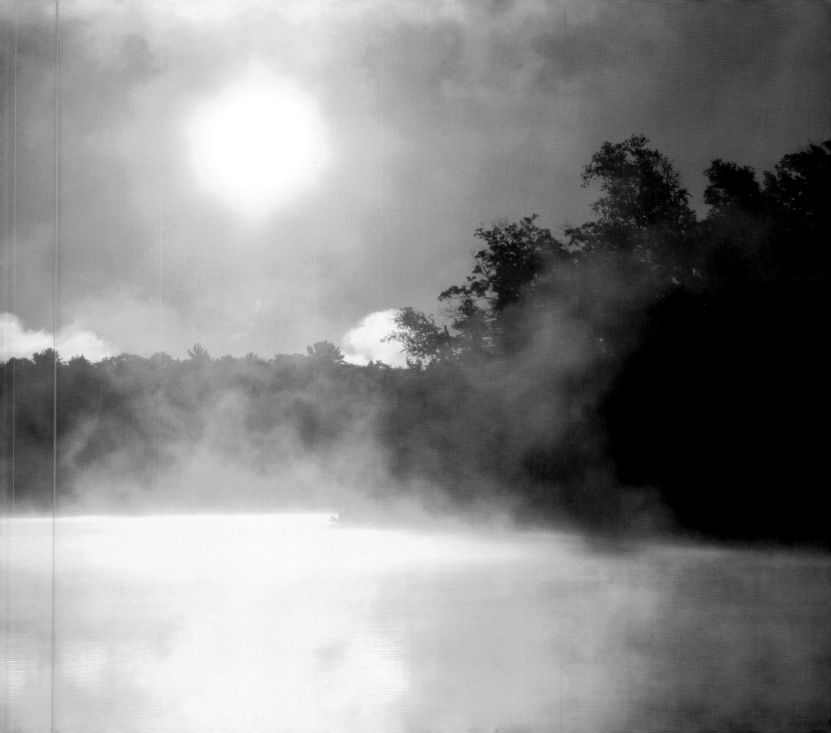

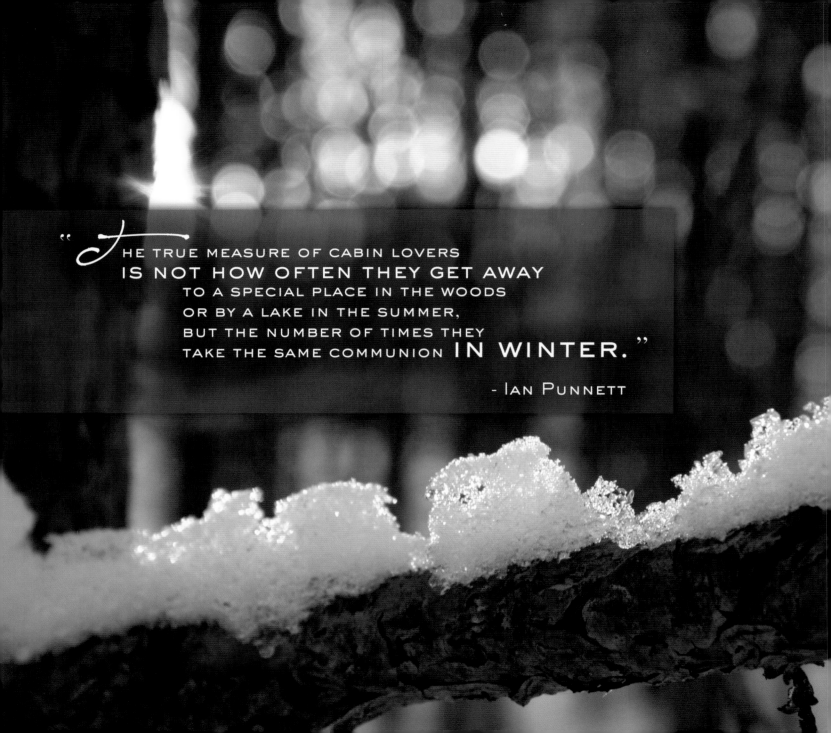

"THE TRUE MEASURE OF CABIN LOVERS
IS NOT HOW OFTEN THEY GET AWAY
TO A SPECIAL PLACE IN THE WOODS
OR BY A LAKE IN THE SUMMER,
BUT THE NUMBER OF TIMES THEY
TAKE THE SAME COMMUNION IN WINTER."

- IAN PUNNETT

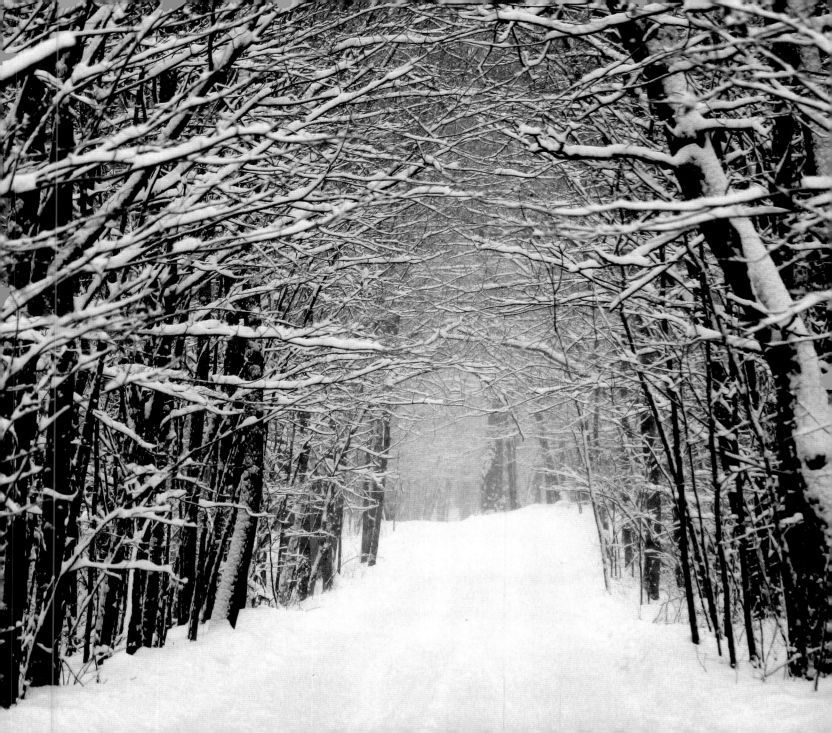

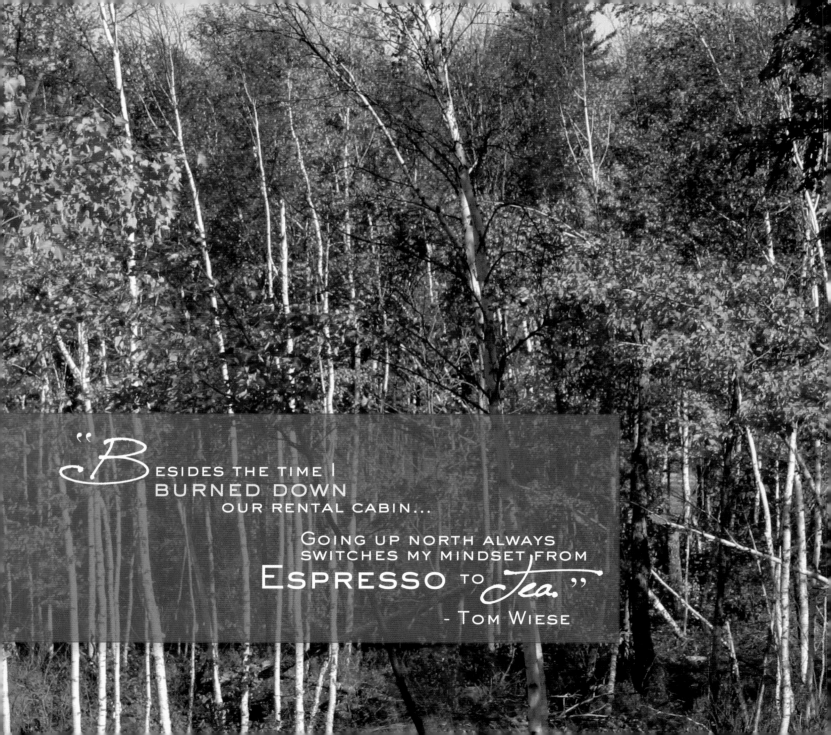

"Besides the time I burned down our rental cabin...

Going up north always switches my mindset from Espresso to Tea."

— Tom Wiese

"The creation of *a thousand forests* " is in one acorn.

– Ralph Waldo Emerson

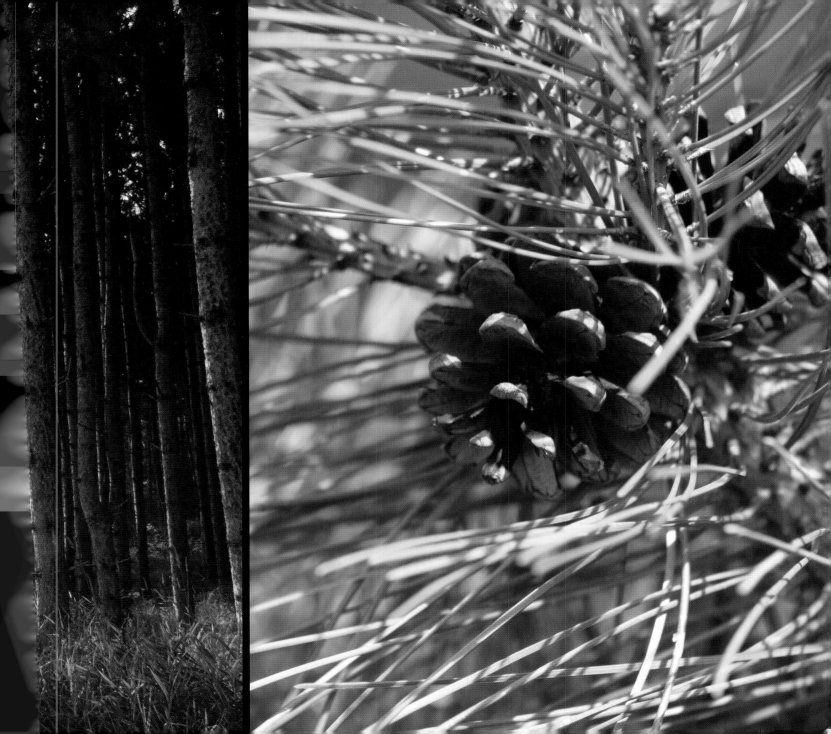

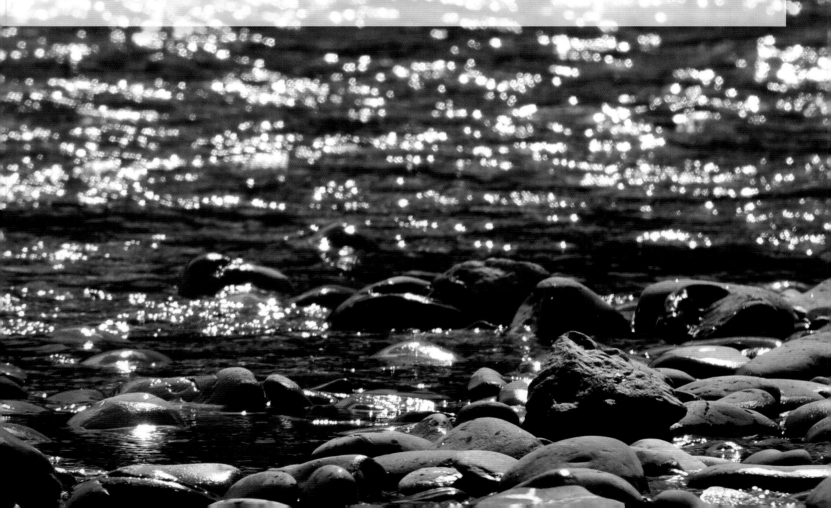

" THE VOLUME OF LIFE CAN CREEP UP SLOWLY...
THE WHITE NOISE OF THE DAILY ROUTINE...
DISTORTION OF UNNECESSARY BUSY-NESS...
GROANS OF A BIG PICTURE LOST IN A TO-DO LIST,
AS THE PEACEFUL VOICE OF OUR OWN NATURE
SEEMS TO GROW FAINTER AND FARTHER AWAY.

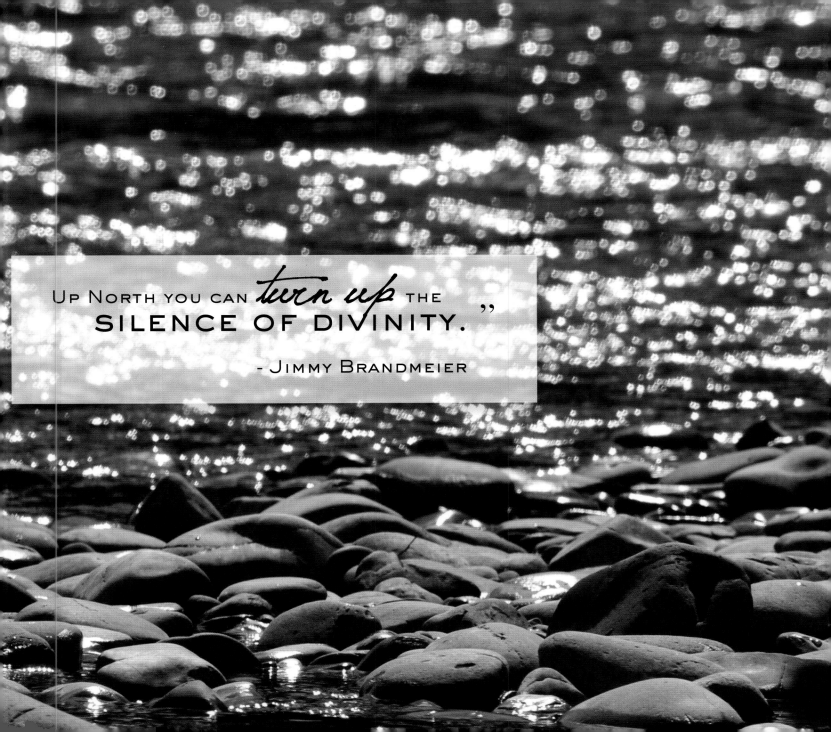

Up North you can *turn up* the SILENCE OF DIVINITY. "

— Jimmy Brandmeier

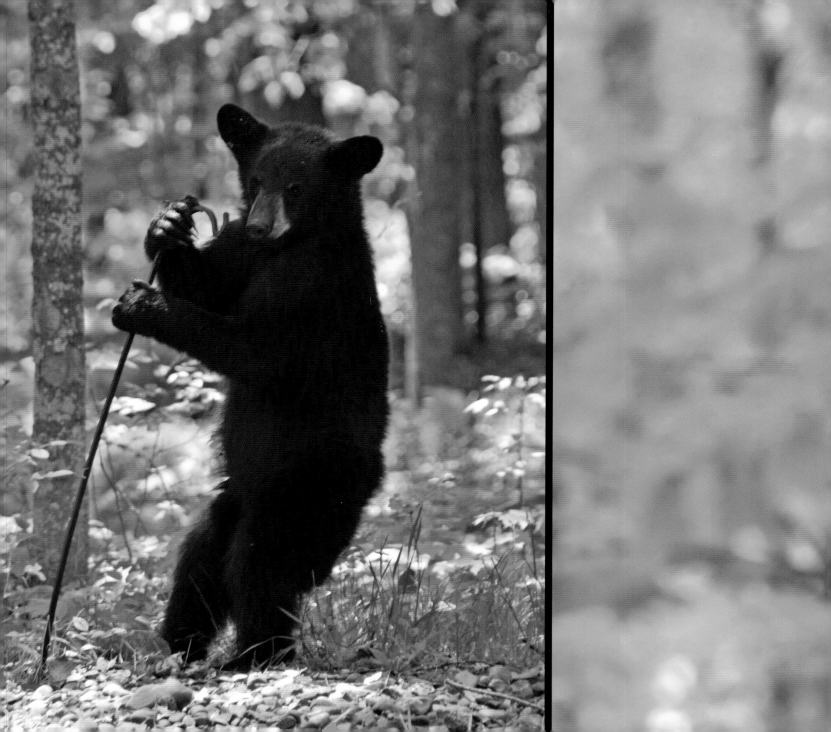

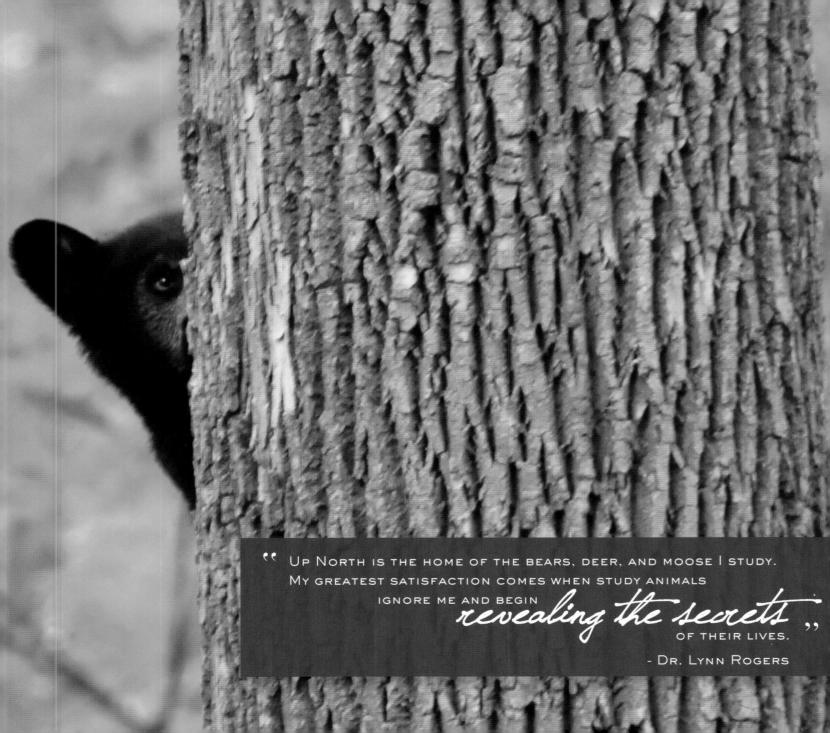

"Up North is the home of the bears, deer, and moose I study. My greatest satisfaction comes when study animals ignore me and begin *revealing the secrets* of their lives."

- Dr. Lynn Rogers

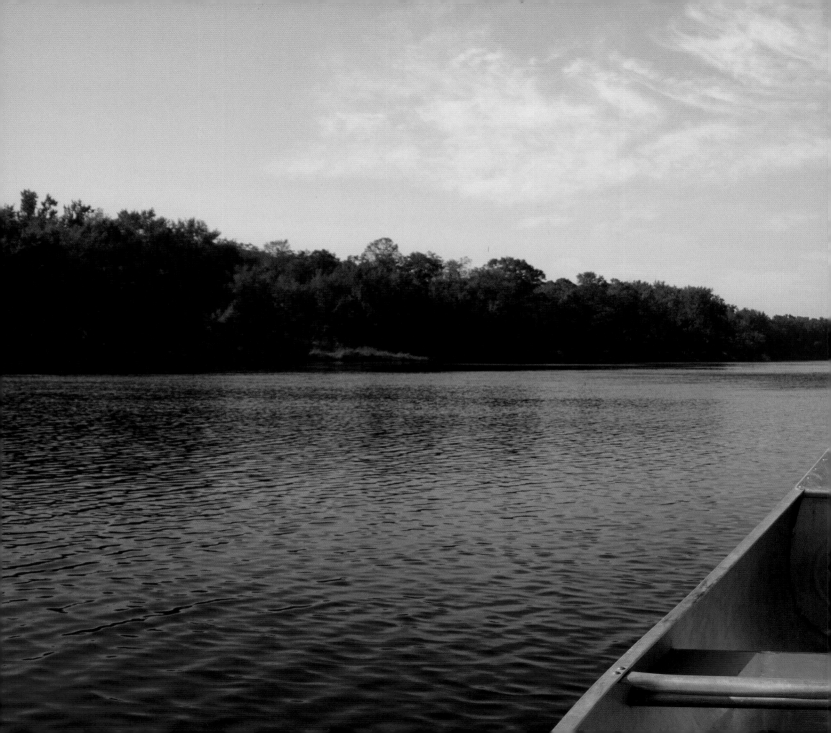

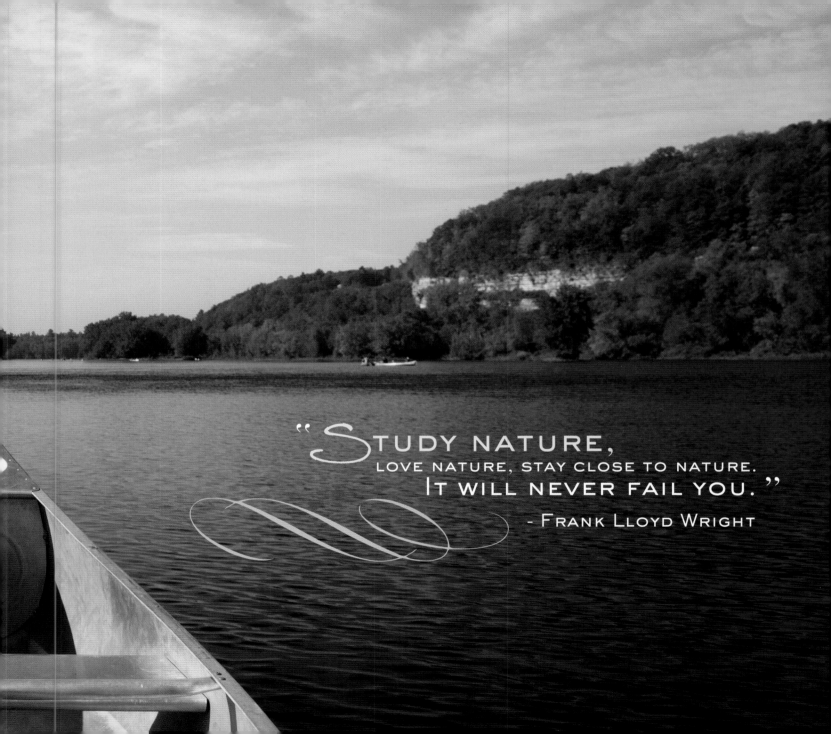

"STUDY NATURE,
love nature, stay close to nature.
It will never fail you."
- Frank Lloyd Wright

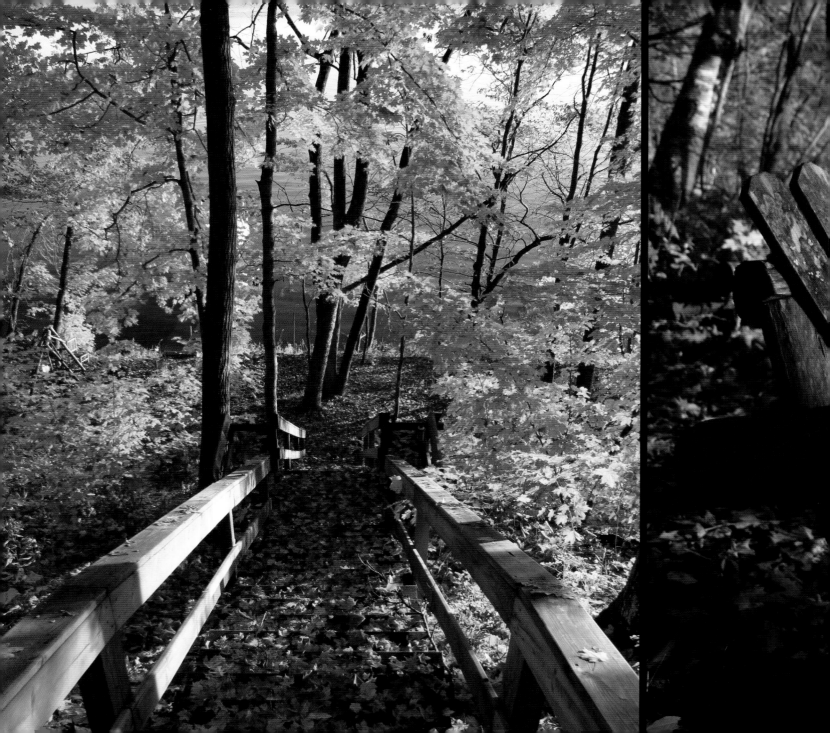

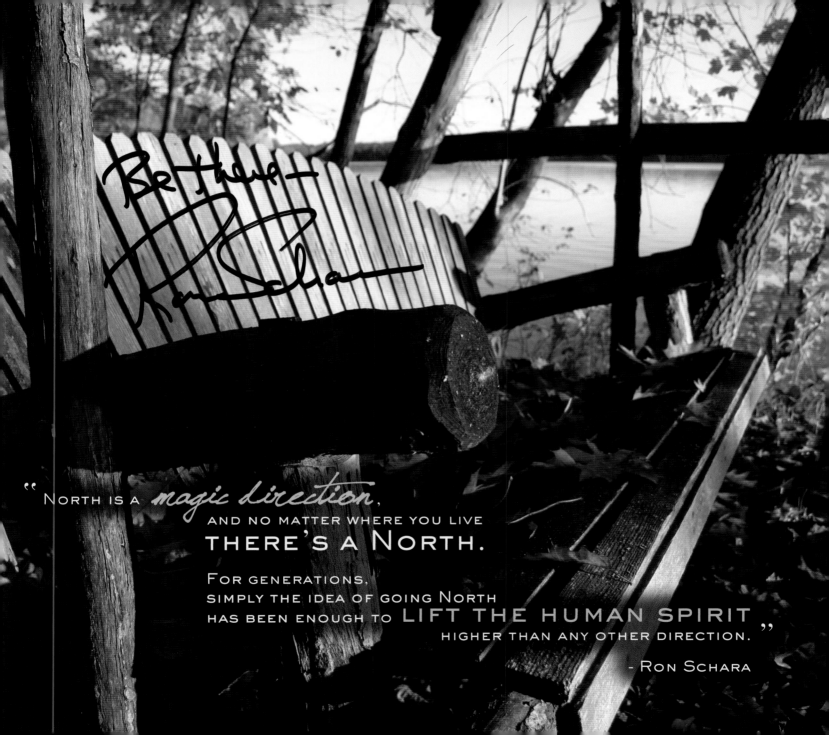

Be Three —
Ron Schara

" North is a *magic direction*,
AND NO MATTER WHERE YOU LIVE
THERE'S A NORTH.

FOR GENERATIONS,
SIMPLY THE IDEA OF GOING NORTH
HAS BEEN ENOUGH TO LIFT THE HUMAN SPIRIT "
HIGHER THAN ANY OTHER DIRECTION.

– RON SCHARA

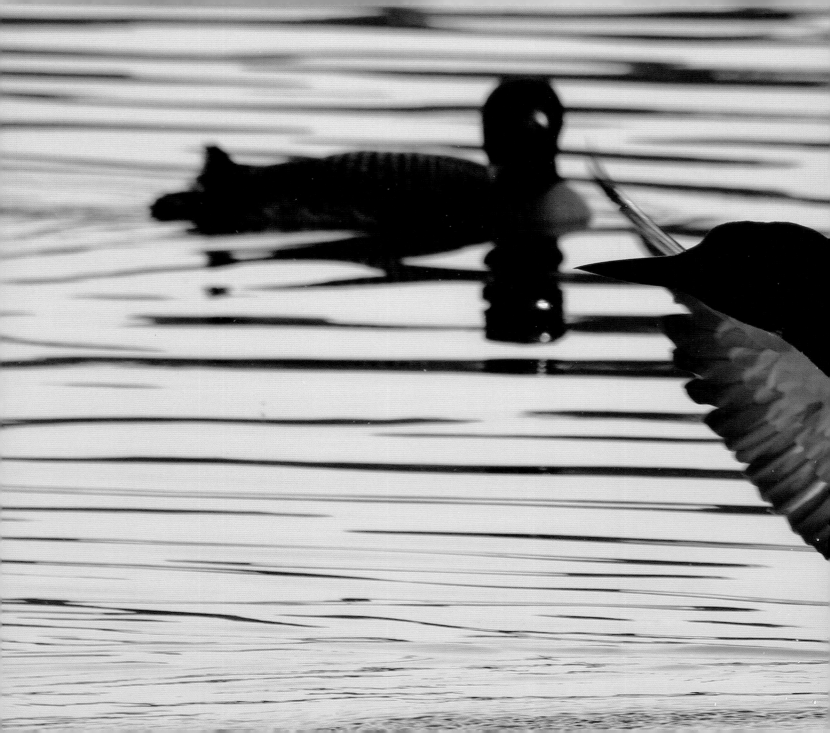

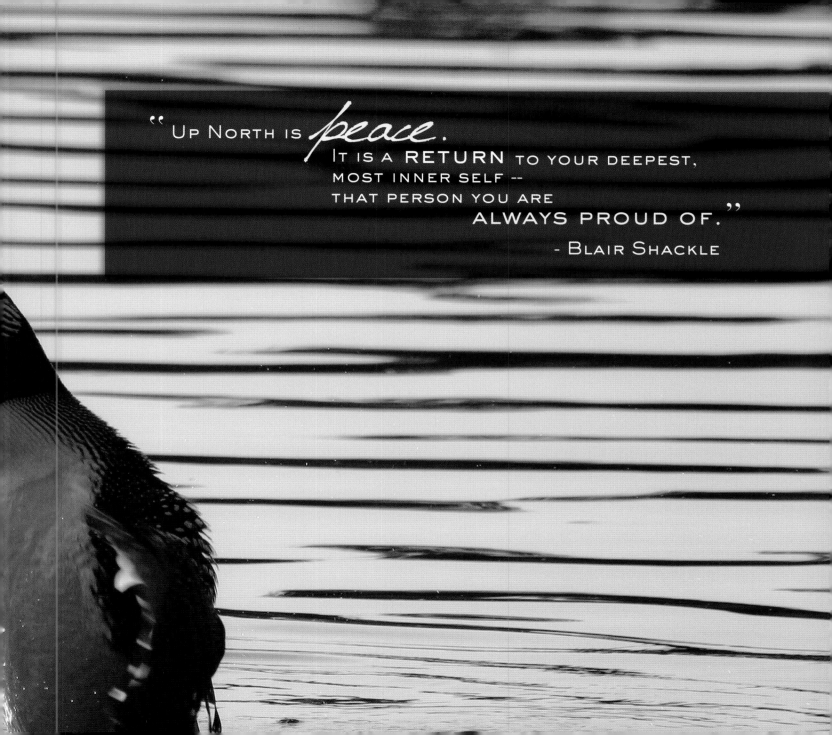

"Up North is *peace*. It is a RETURN to your deepest, most inner self -- that person you are ALWAYS PROUD OF."

- Blair Shackle

"THE EARTH *laughs* IN FLOWERS."

- RALPH WALDO EMERSON

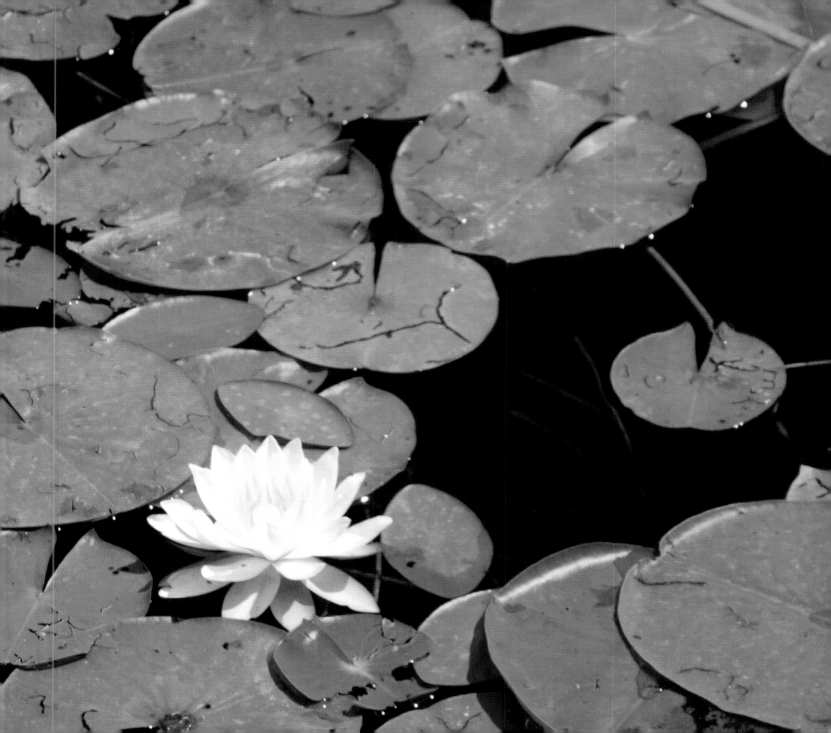

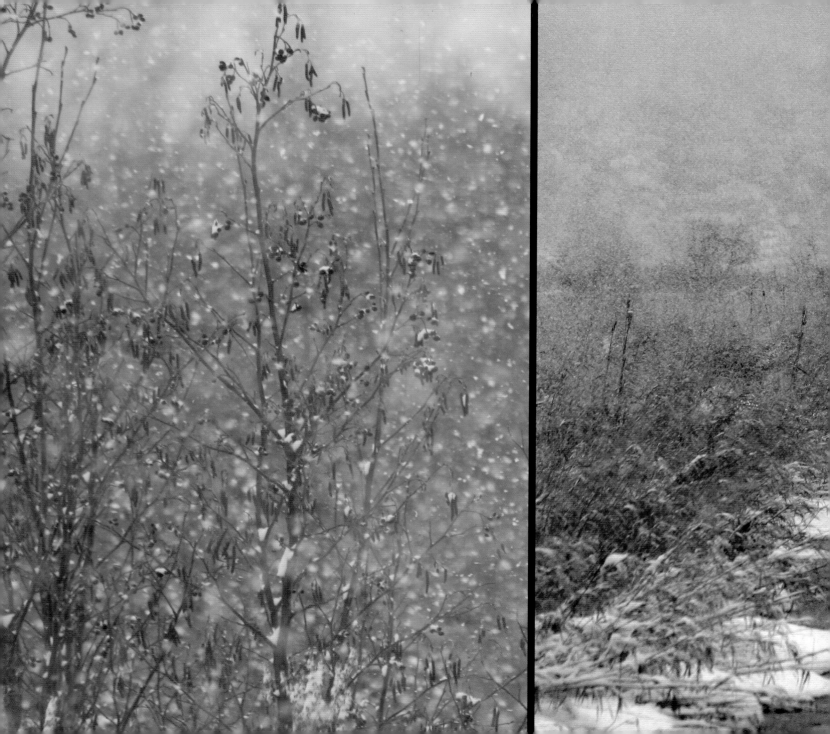

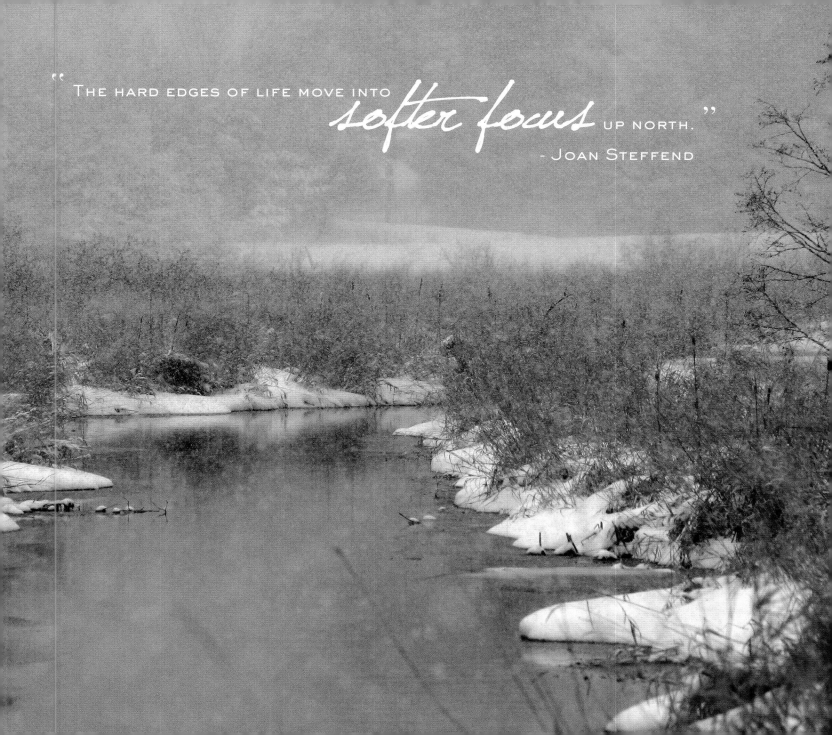

"THE HARD EDGES OF LIFE MOVE INTO *softer focus* UP NORTH."

— JOAN STEFFEND

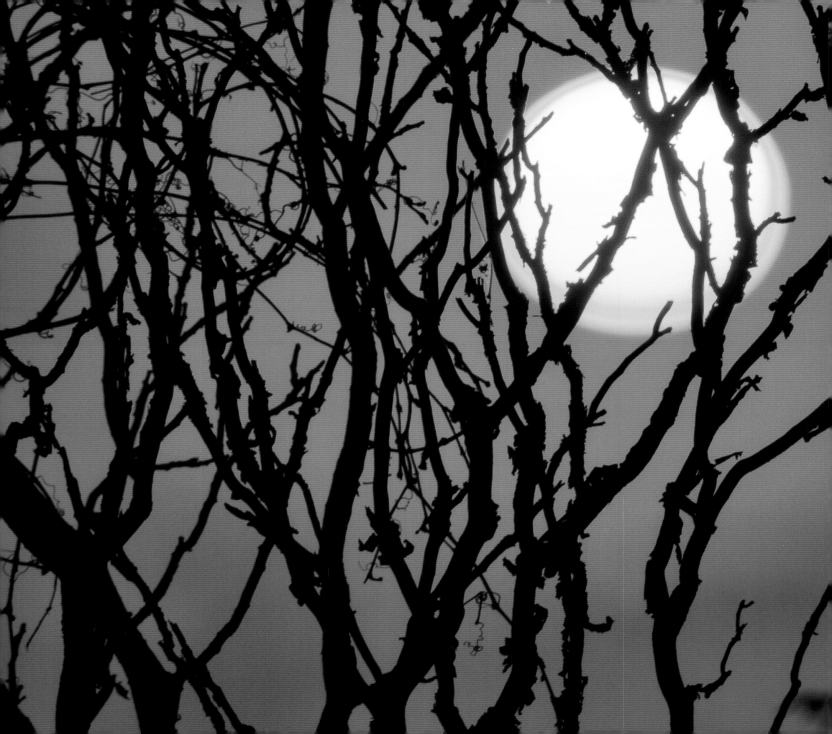

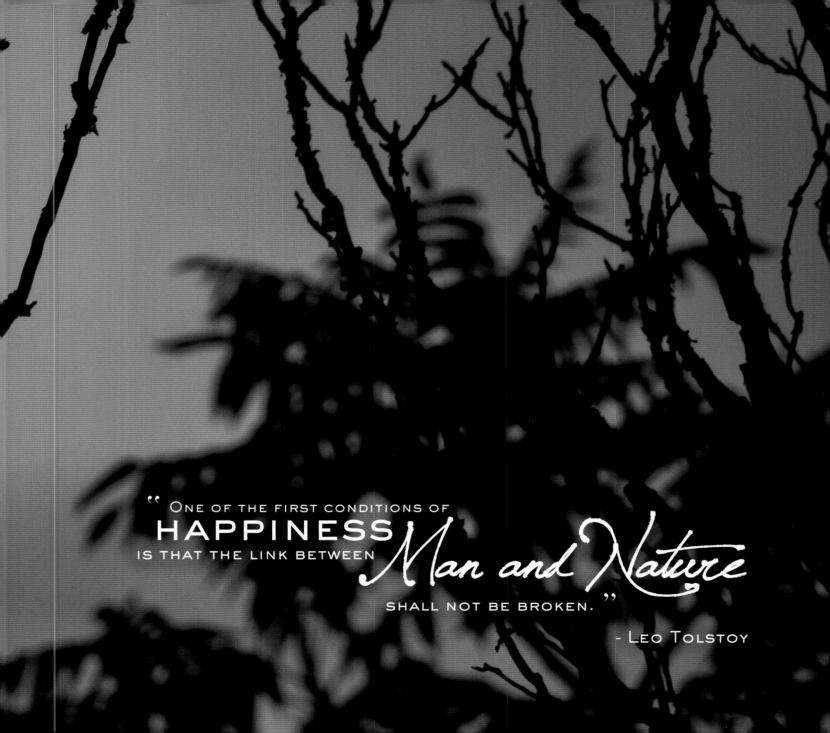

" One of the first conditions of
HAPPINESS
is that the link between *Man and Nature*
shall not be broken. "

- Leo Tolstoy

"It's something unexplainable, but somehow, THE MOMENT MY FISHING LINE HITS THE WATER, all my stress and daily frustrations disappear... and it all gives way to the new stress and frustration about CATCHING THE DANG FISH!"

- Bryan Shackle

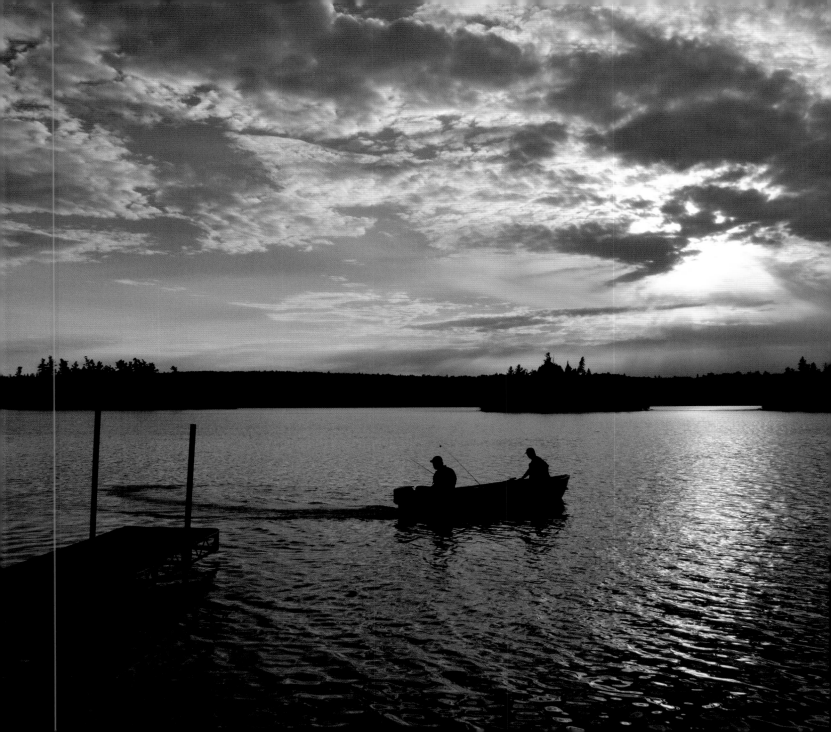

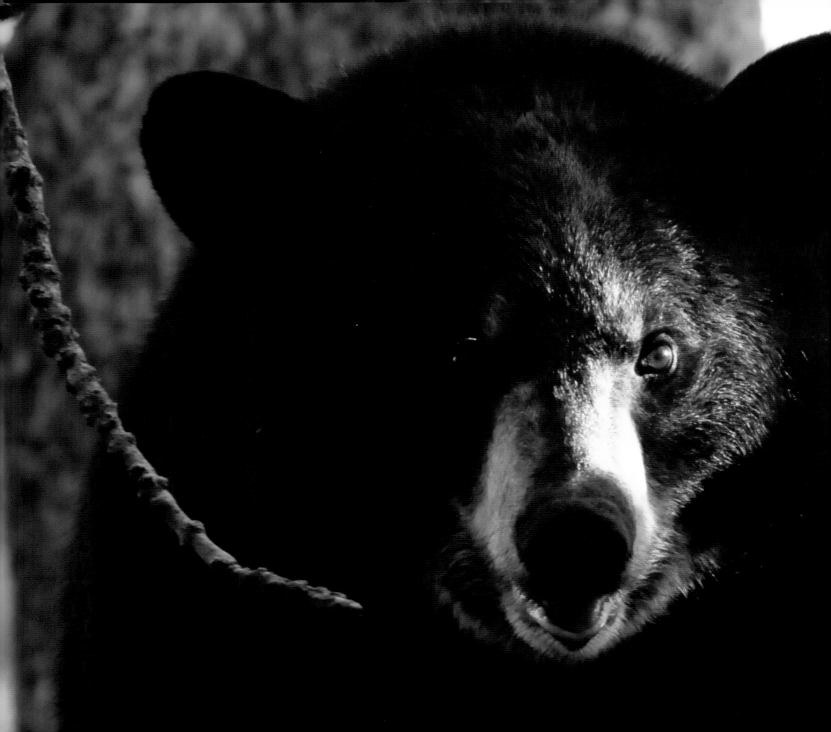

> " WHAT IS MAN WITHOUT THE BEASTS?
> IF ALL THE BEASTS WERE GONE,
> MEN WOULD DIE FROM LONELINESS OF SPIRIT,
> FOR WHATEVER HAPPENS TO THE BEAST, HAPPENS TO MAN.
> ALL THINGS ARE CONNECTED. "
>
> - CHIEF SEATTLE

" Up north is *peace*. "

- Mary Mahoney

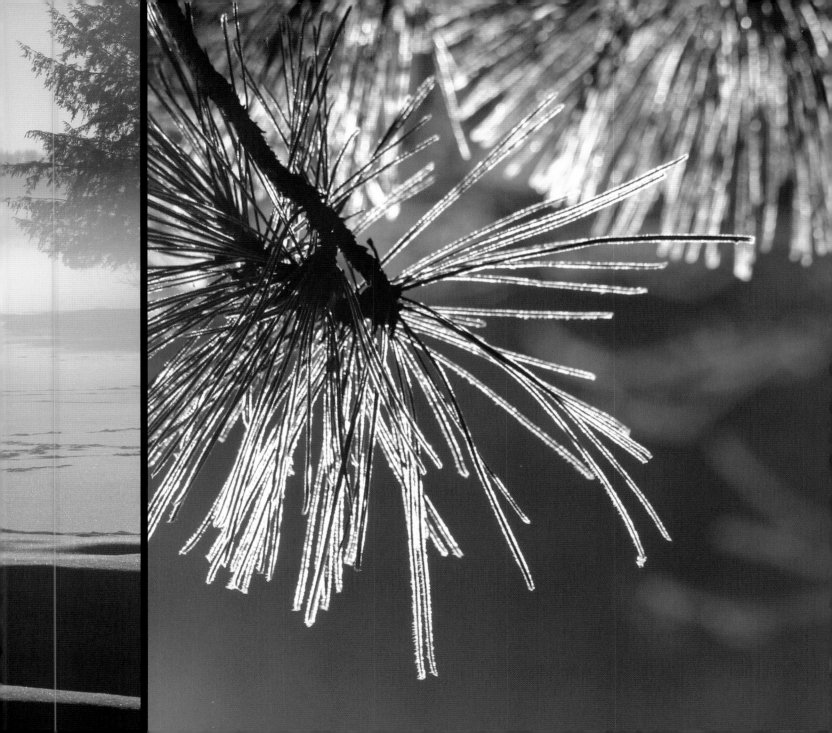

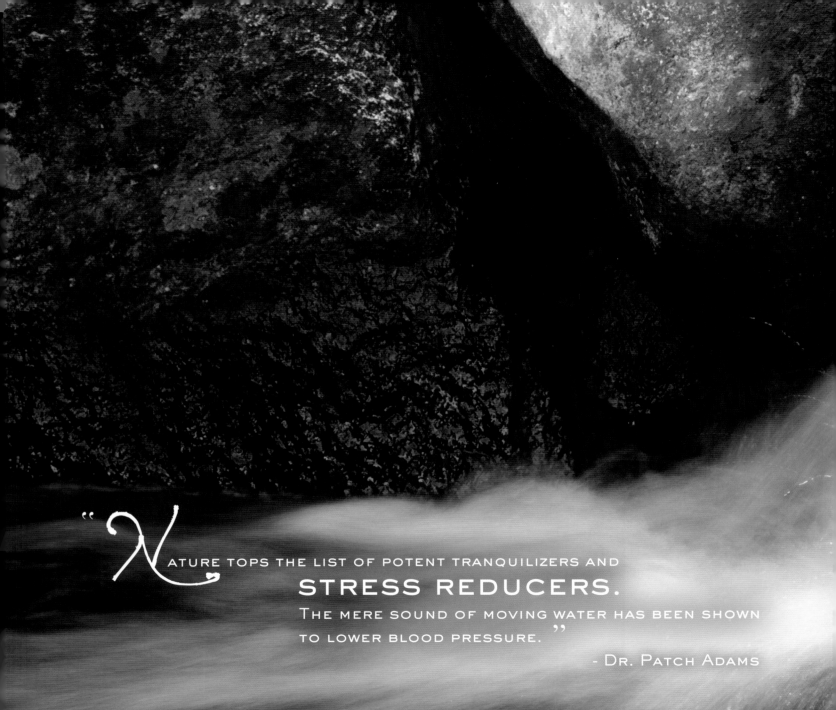

" **N**ATURE TOPS THE LIST OF POTENT TRANQUILIZERS AND
STRESS REDUCERS.
THE MERE SOUND OF MOVING WATER HAS BEEN SHOWN
TO LOWER BLOOD PRESSURE. "

- DR. PATCH ADAMS

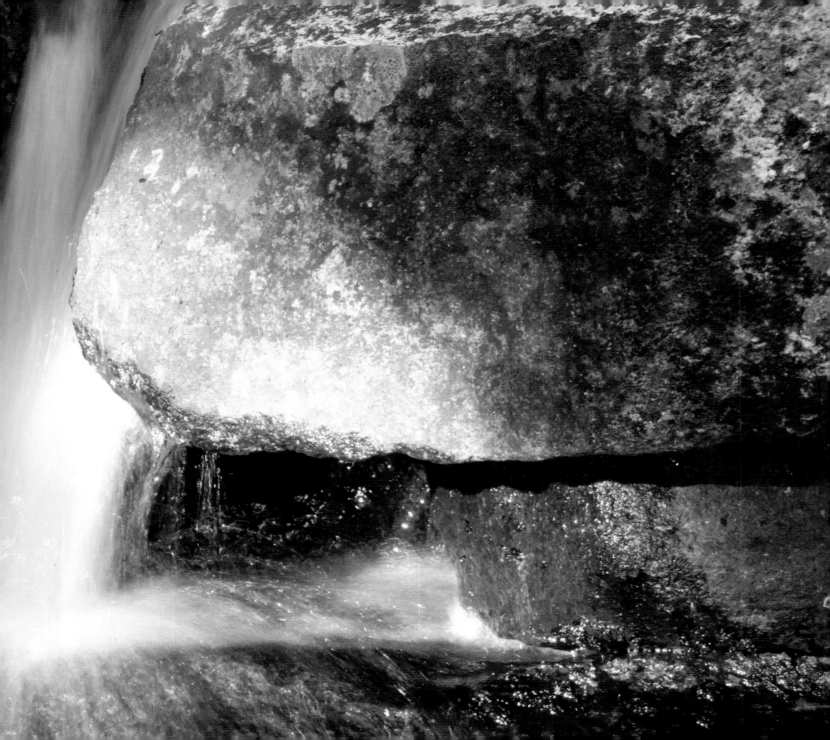

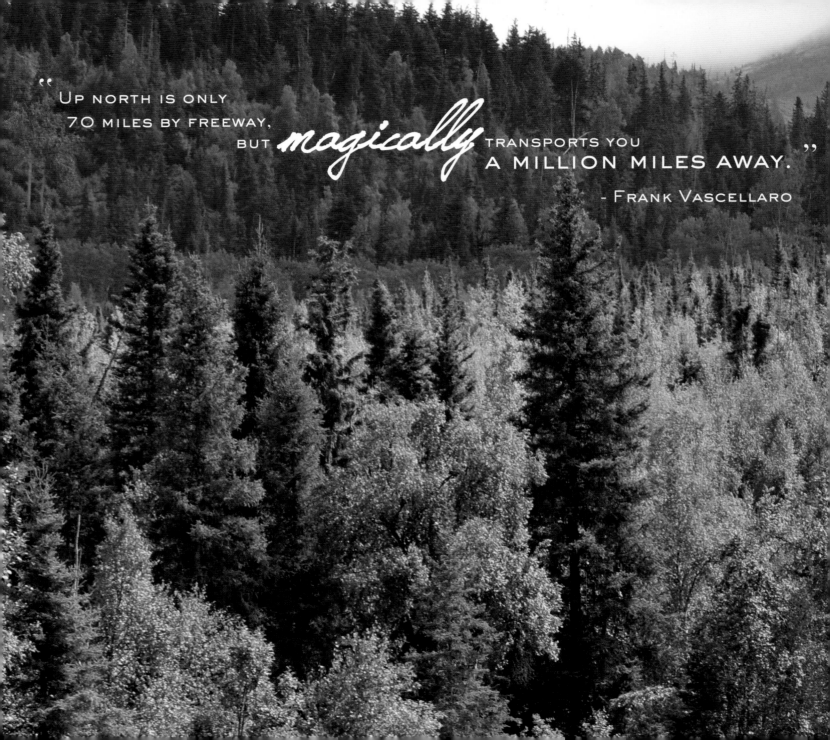

" UP NORTH IS ONLY
70 MILES BY FREEWAY,
BUT *magically* TRANSPORTS YOU
A MILLION MILES AWAY. "

- FRANK VASCELLARO

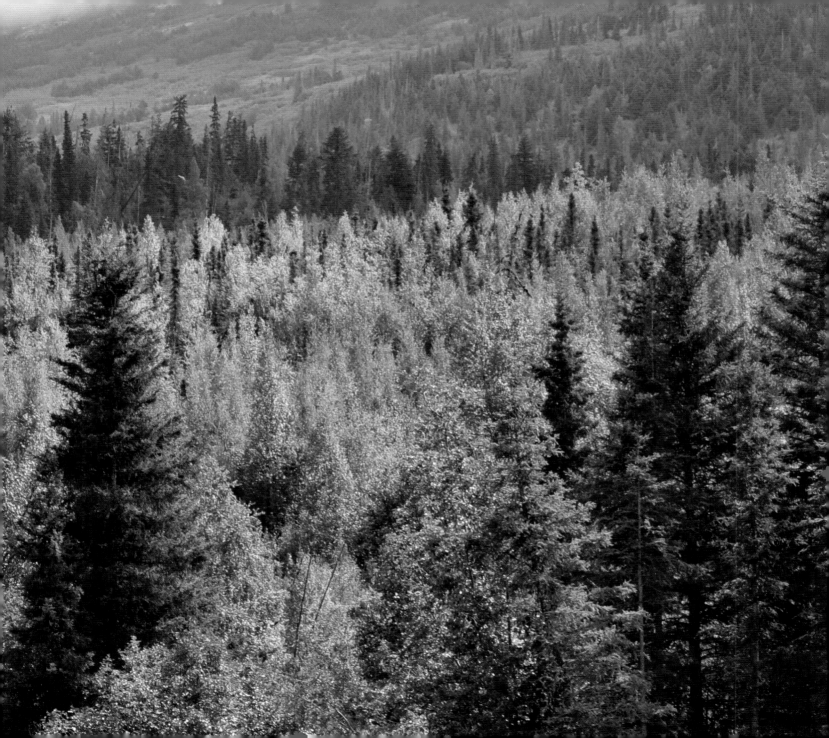

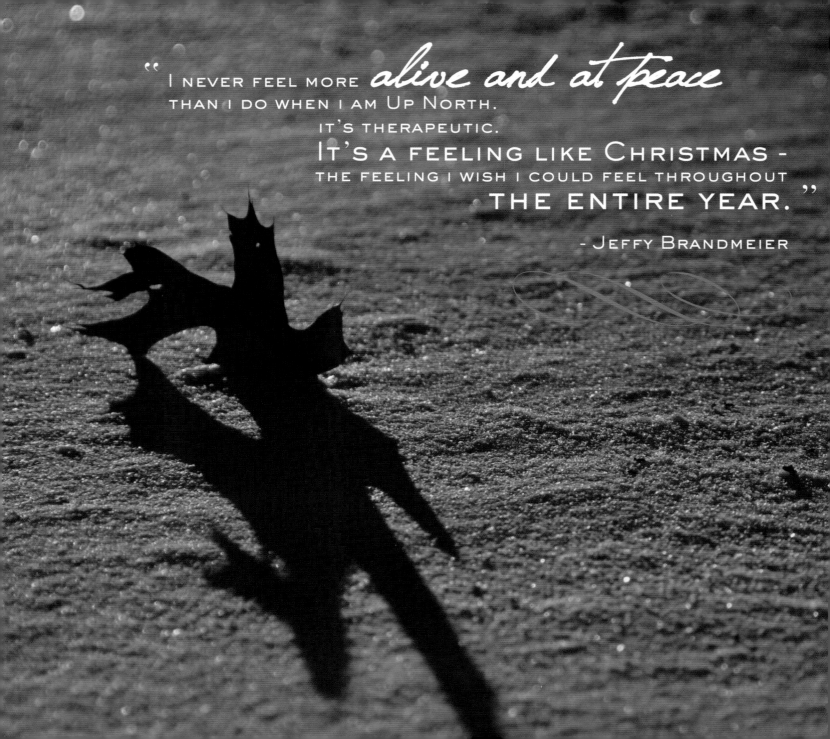

"I NEVER FEEL MORE *alive and at peace* THAN I DO WHEN I AM UP NORTH. IT'S THERAPEUTIC. IT'S A FEELING LIKE CHRISTMAS – THE FEELING I WISH I COULD FEEL THROUGHOUT THE ENTIRE YEAR."

- JEFFY BRANDMEIER

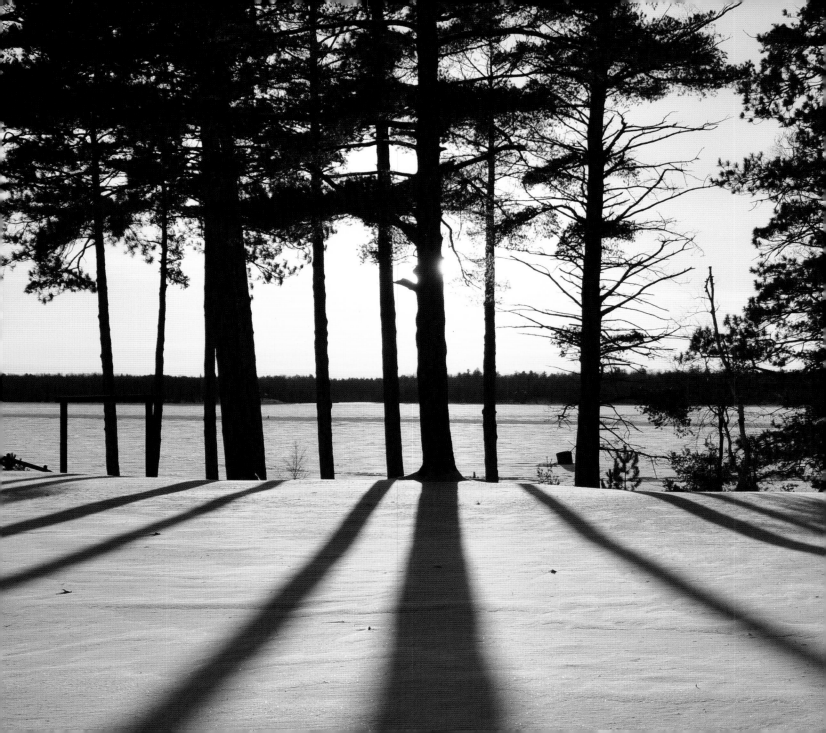

" THE MAGICAL HOUR UP NORTH
IS EARLY IN THE MORNING.
I LOVE IT THEN, OUT ON THE DOCK,
LISTENING TO THE LAKE WAKE UP.
THE LOONS, THE WAVES, THE WIND IN THE PINES,
AND THE *warm sunshine* -
IT MAKES ME FEEL MILES AWAY FROM THE RUSH
OF A NORMAL DAY IN THE CITY. "

- BELINDA JENSEN

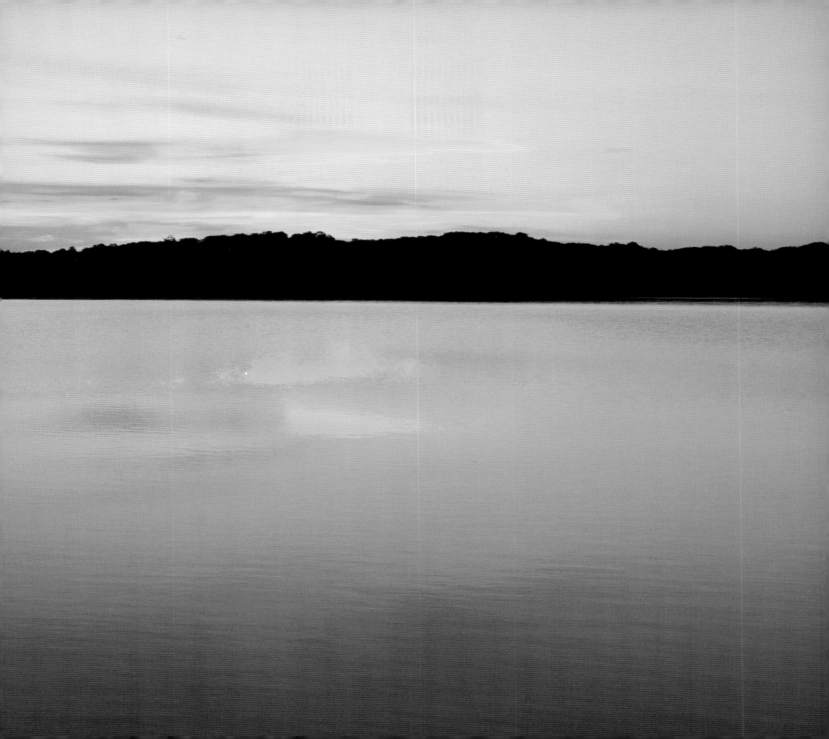

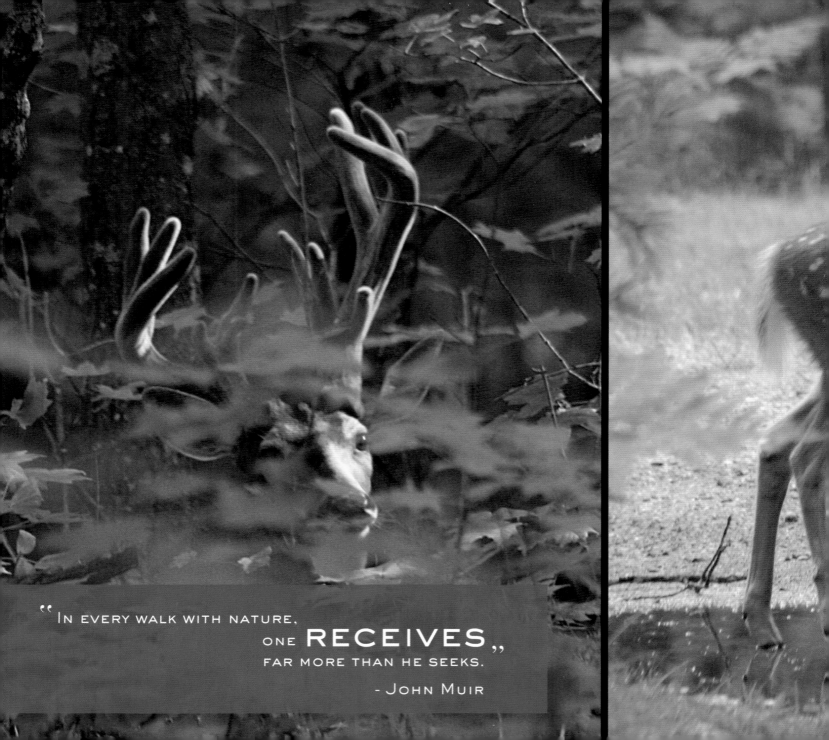

" IN EVERY WALK WITH NATURE,

ONE **RECEIVES** ,,
FAR MORE THAN HE SEEKS.

- JOHN MUIR

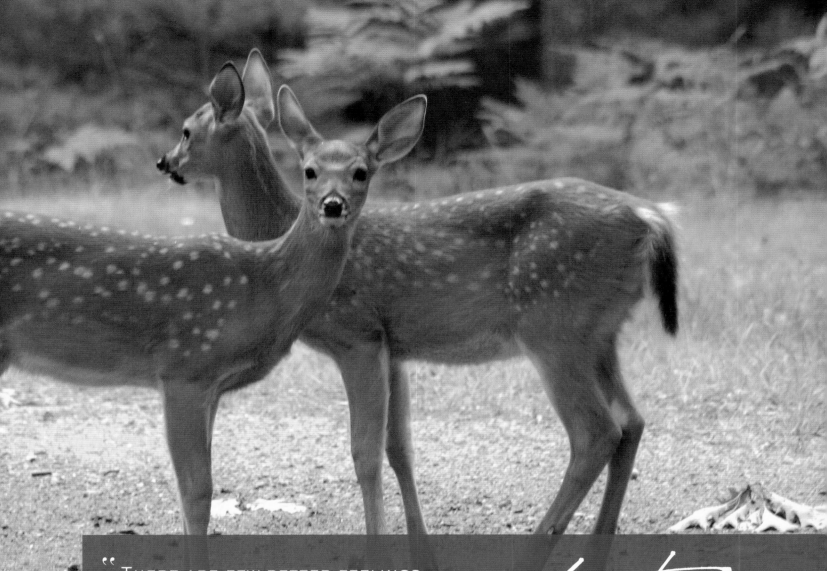

"THERE ARE FEW BETTER FEELINGS THAN BEING SURROUNDED BY THE *beauty* OF NATURE AND THE SOUNDS OF LAUGHTER FROM THOSE YOU LOVE."

- JORDAN BRANDMEIER

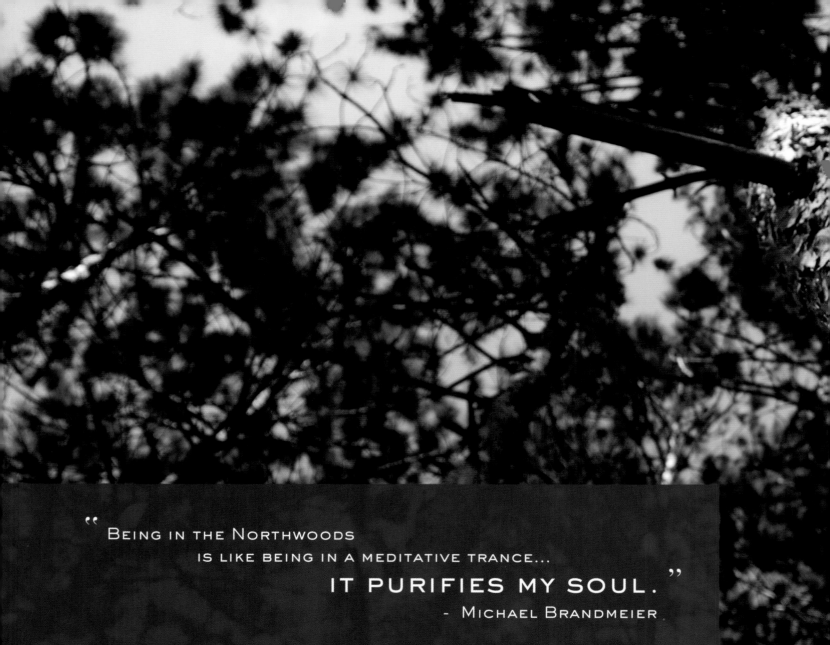

"BEING IN THE NORTHWOODS
IS LIKE BEING IN A MEDITATIVE TRANCE...
IT PURIFIES MY SOUL."
- MICHAEL BRANDMEIER

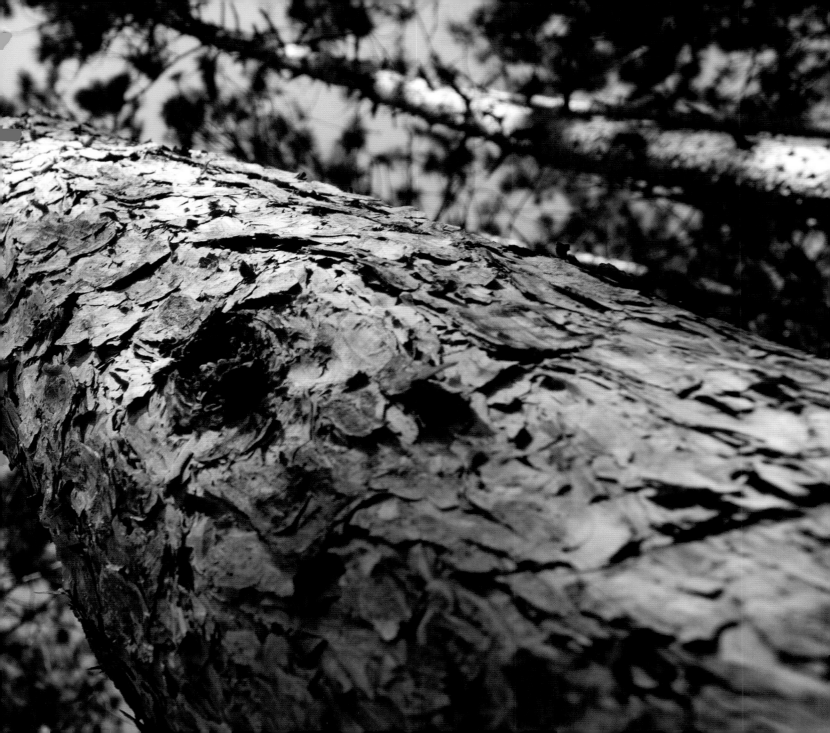

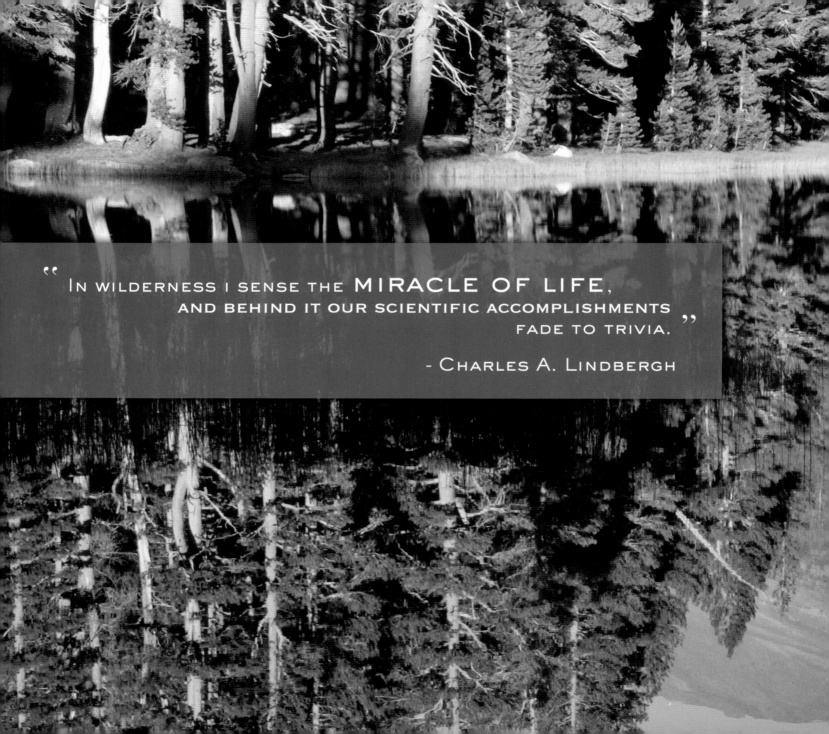

"IN WILDERNESS I SENSE THE **MIRACLE OF LIFE**, AND BEHIND IT OUR SCIENTIFIC ACCOMPLISHMENTS FADE TO TRIVIA."

- CHARLES A. LINDBERGH

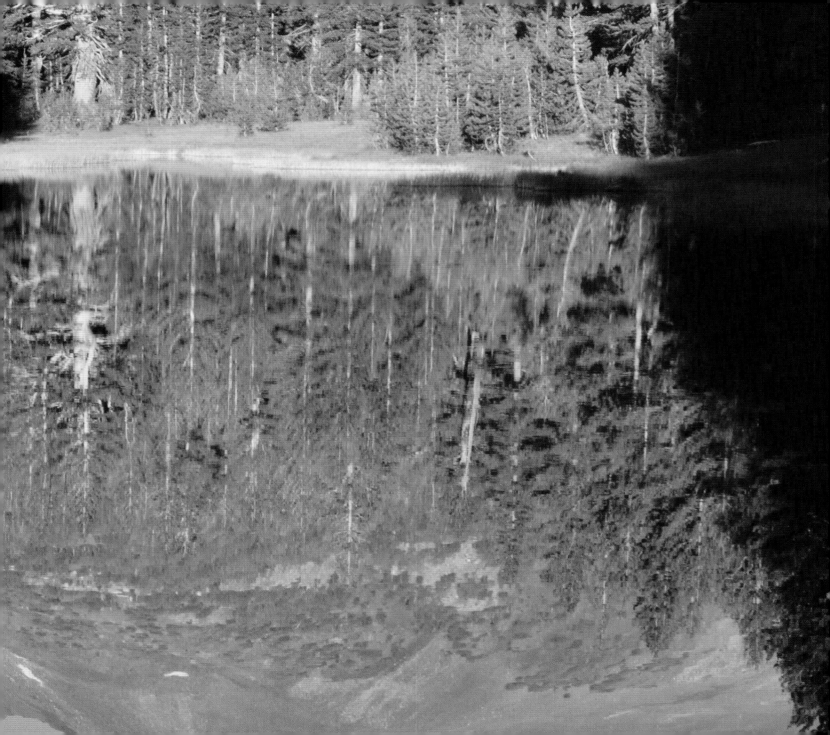

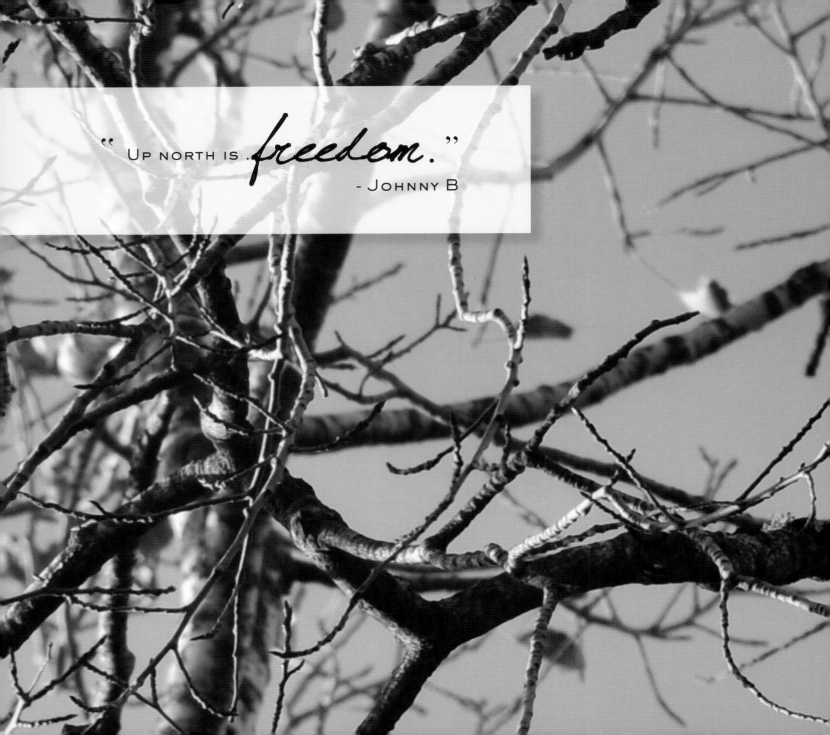

" Up north is .*freedom*. "
- Johnny B

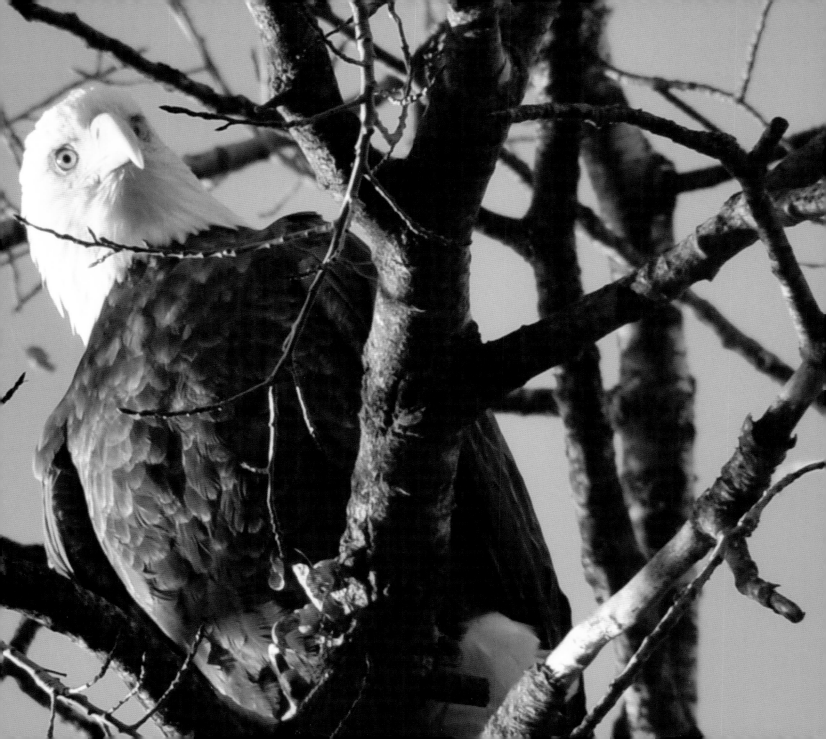

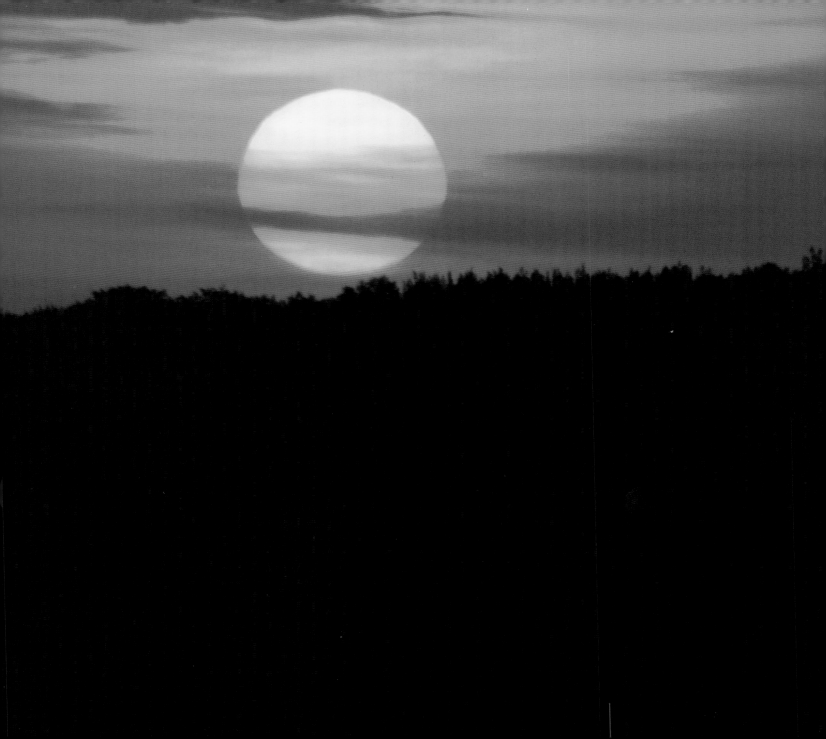

"Up North is hunting, fishing, the northern lights,
a billion stars, the laughter of kids splashing as they swim,
the sun setting over a beautiful lake,
and the solitude of not being near a big city. . .
There's nothing like it!"
- Babe Winkelman

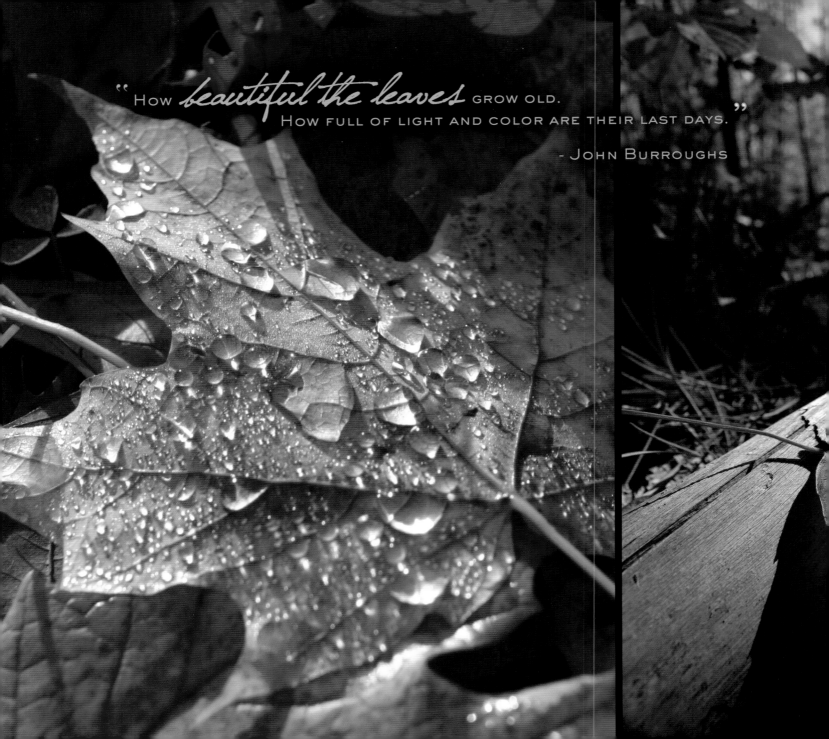

"How *beautiful the leaves* GROW OLD. HOW FULL OF LIGHT AND COLOR ARE THEIR LAST DAYS."

- JOHN BURROUGHS

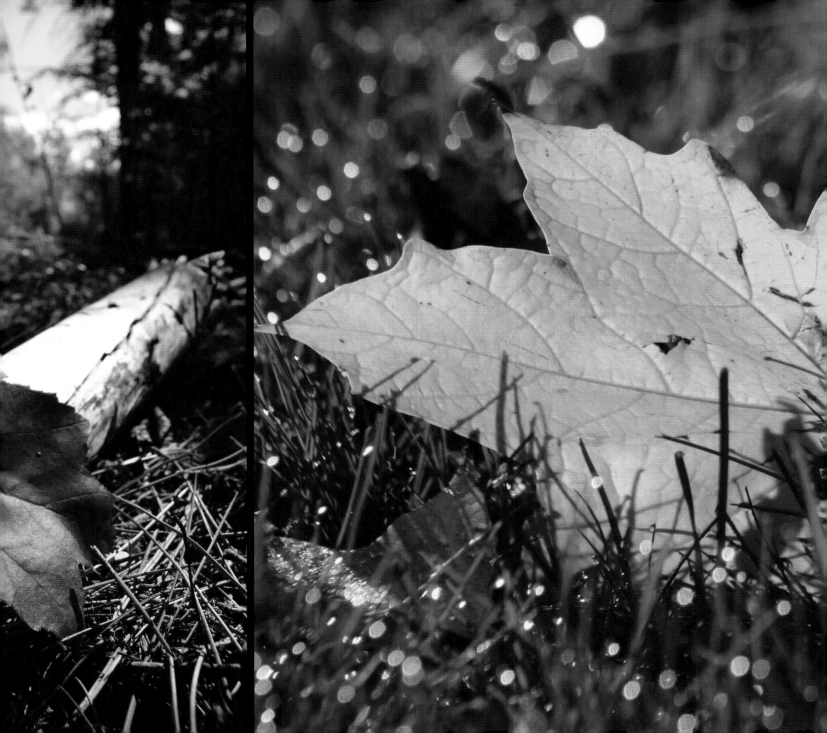

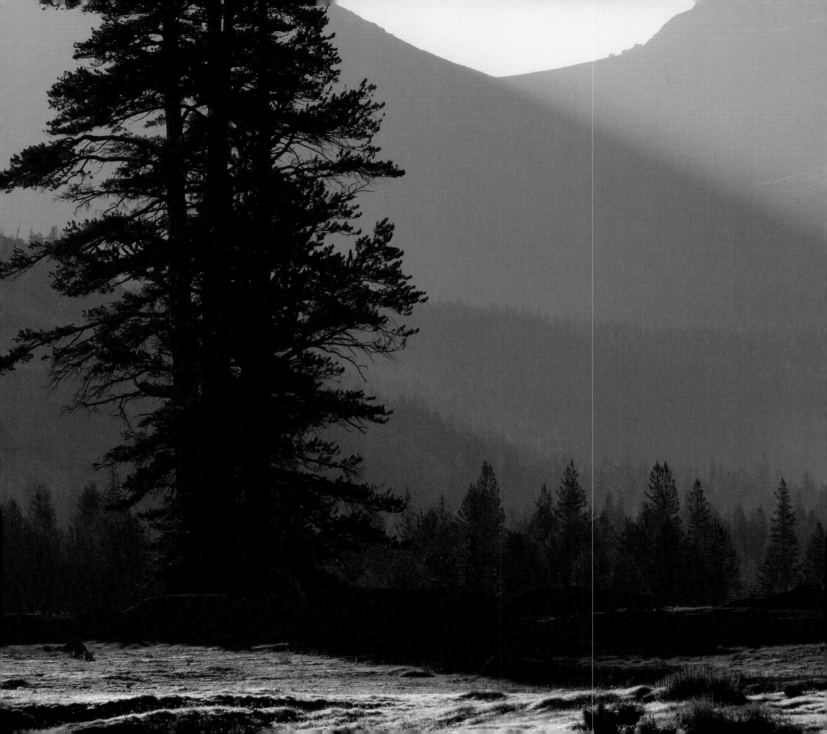

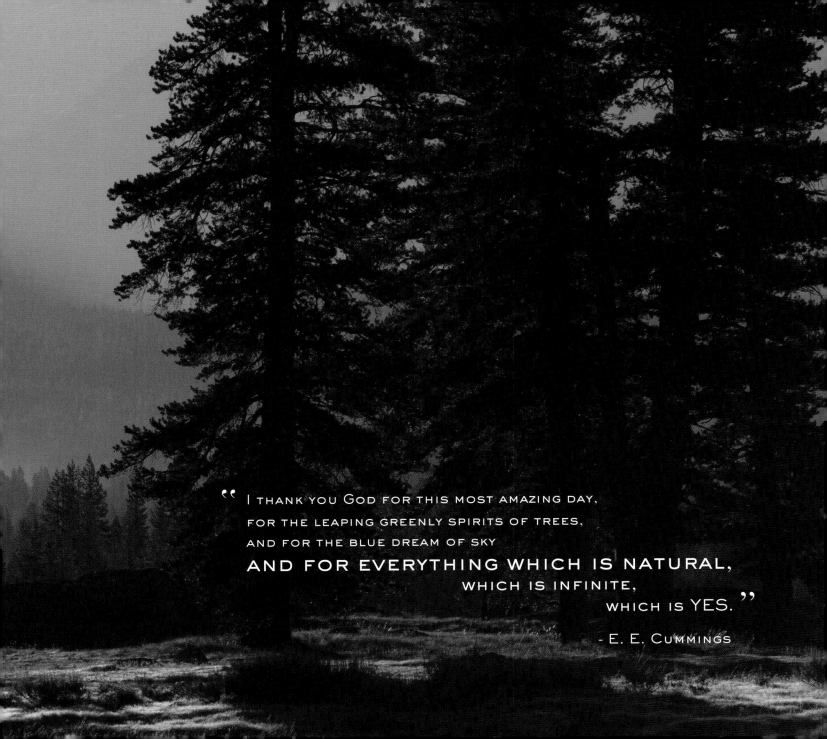

" I thank you God for this most amazing day,
for the leaping greenly spirits of trees,
and for the blue dream of sky
AND FOR EVERYTHING WHICH IS NATURAL,
which is infinite,
which is YES. "

- E. E. Cummings

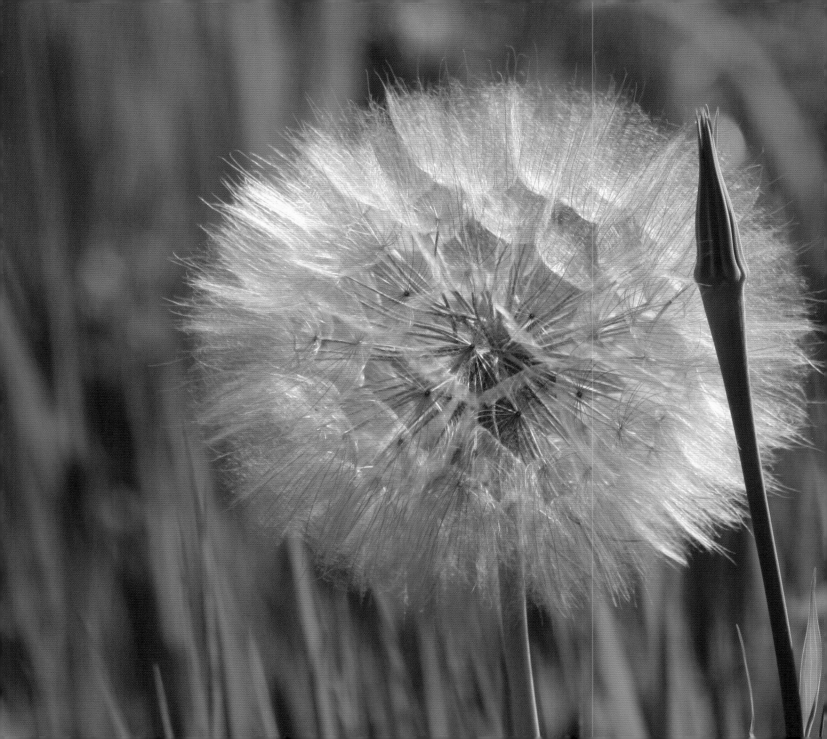

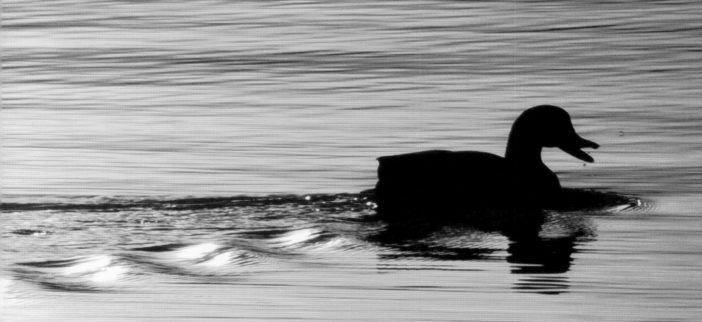

"Nature does not hurry,
yet everything is accomplished."

- Lao Tzu

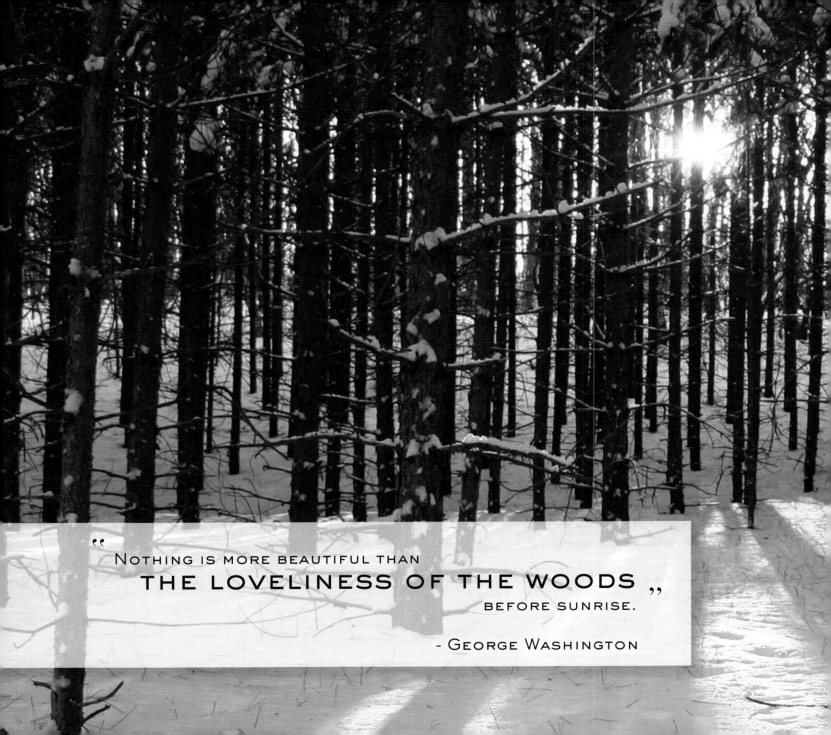

" NOTHING IS MORE BEAUTIFUL THAN
THE LOVELINESS OF THE WOODS ,,
BEFORE SUNRISE.

- GEORGE WASHINGTON

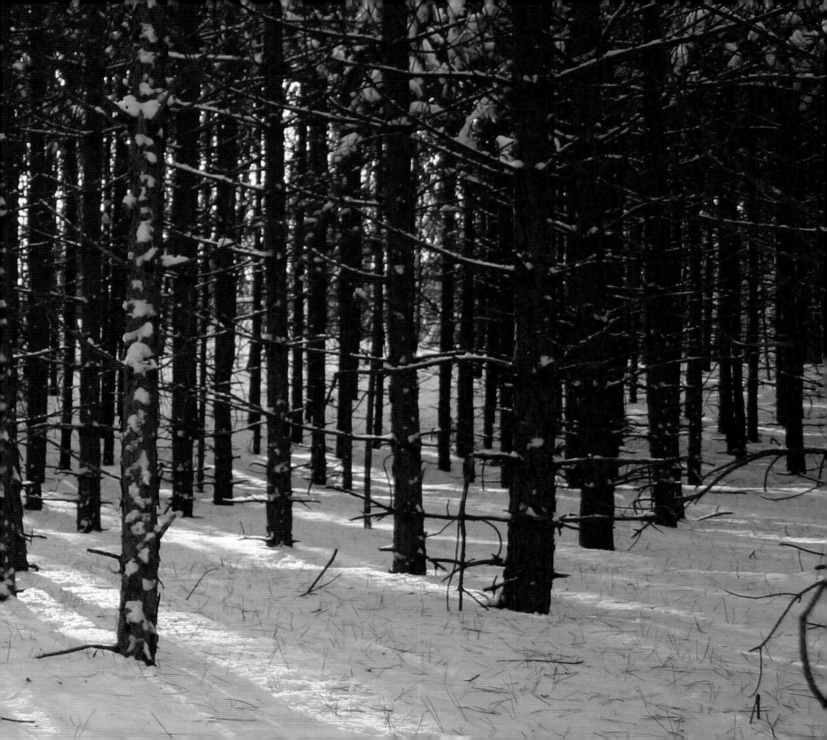

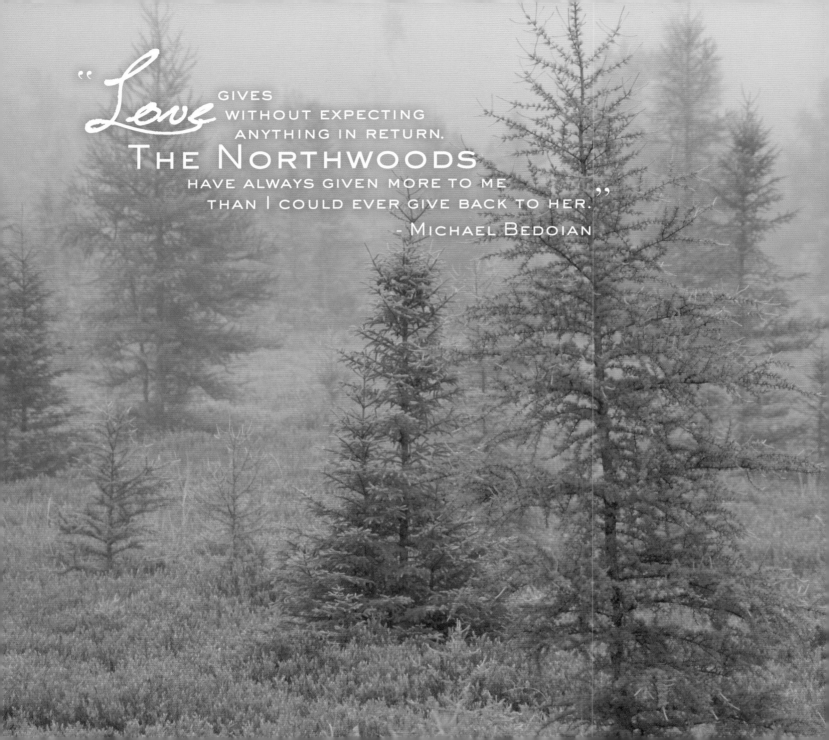

"*Love* GIVES
WITHOUT EXPECTING
ANYTHING IN RETURN.
THE NORTHWOODS
HAVE ALWAYS GIVEN MORE TO ME
THAN I COULD EVER GIVE BACK TO HER. "
- MICHAEL BEDOIAN

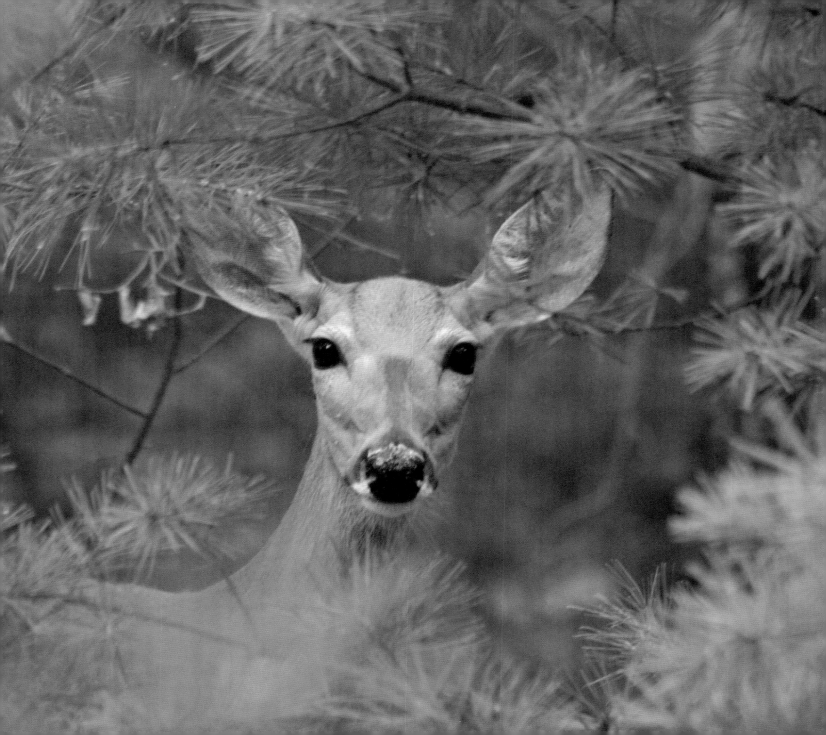

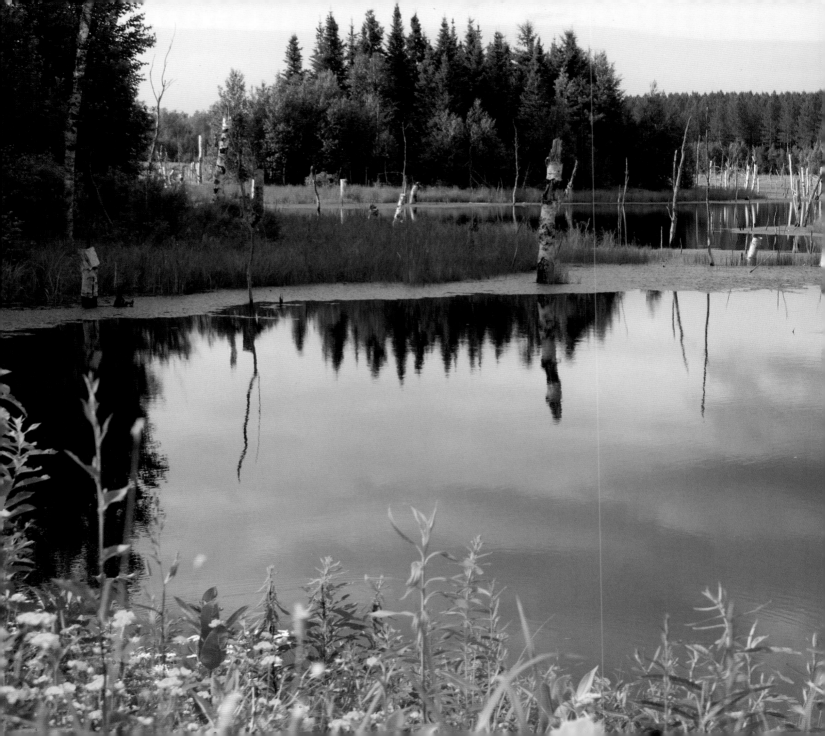

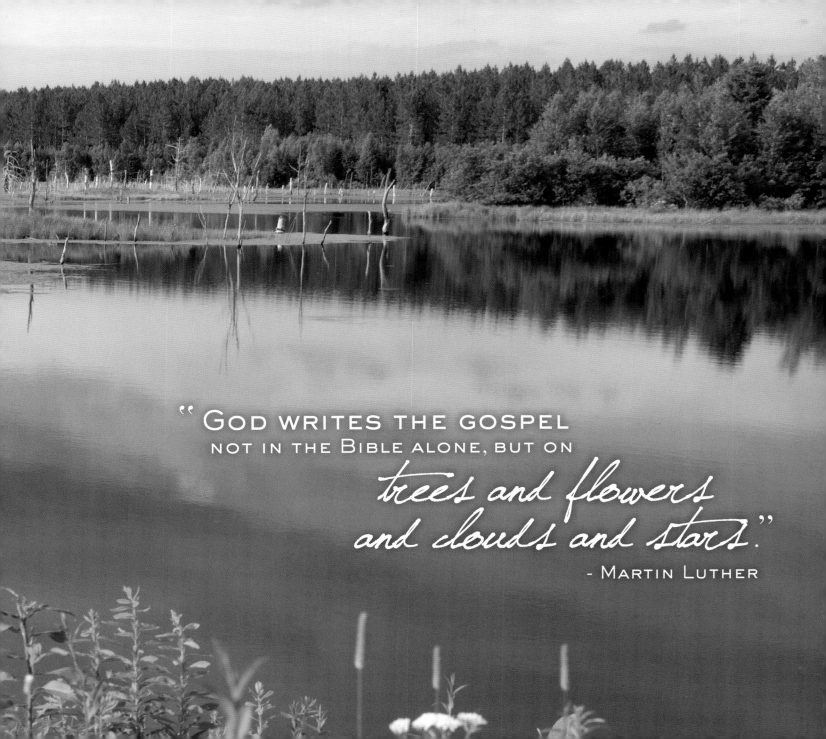

"GOD WRITES THE GOSPEL NOT IN THE BIBLE ALONE, BUT ON *trees and flowers and clouds and stars.*"

- MARTIN LUTHER

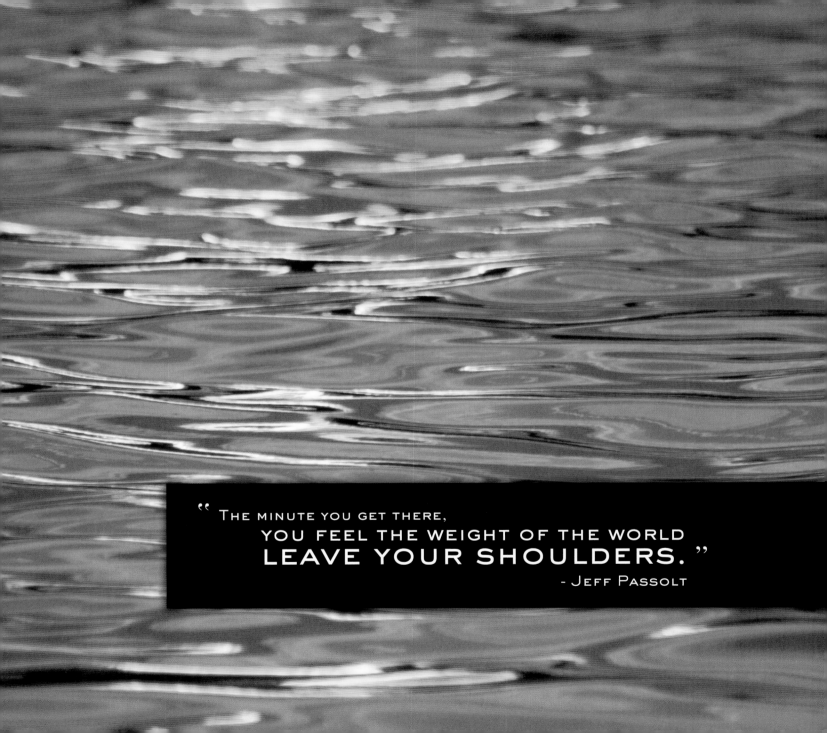

" The minute you get there,
you feel the weight of the world
LEAVE YOUR SHOULDERS. "
- Jeff Passolt

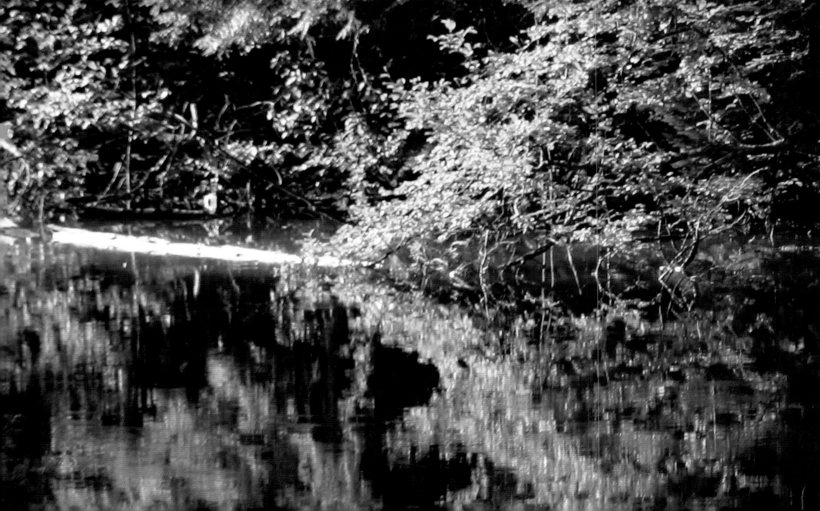

"He is **RICHEST** who is content with the **LEAST**, for content is the *wealth of nature.*"

— Socrates

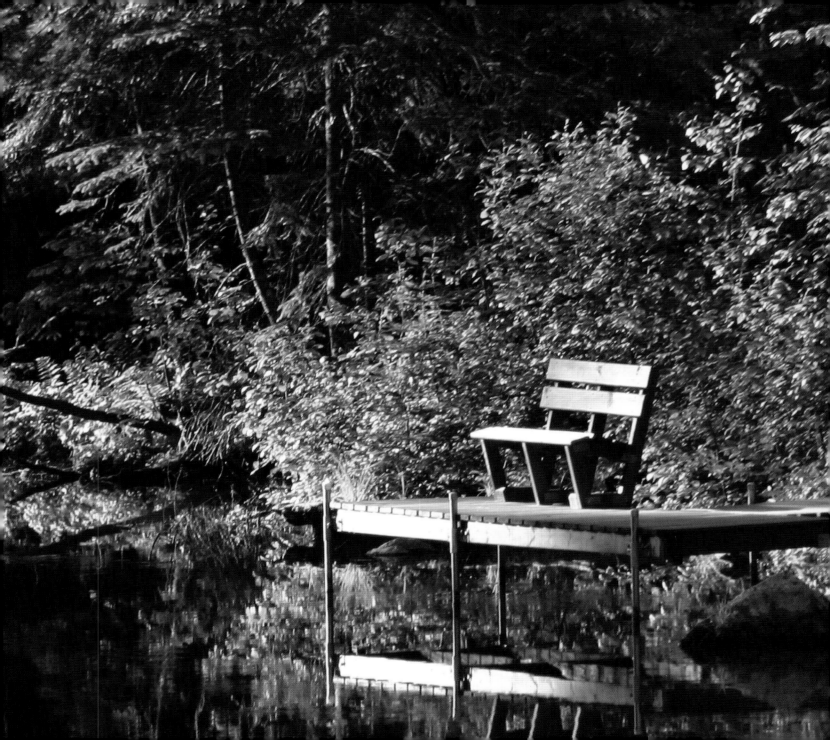

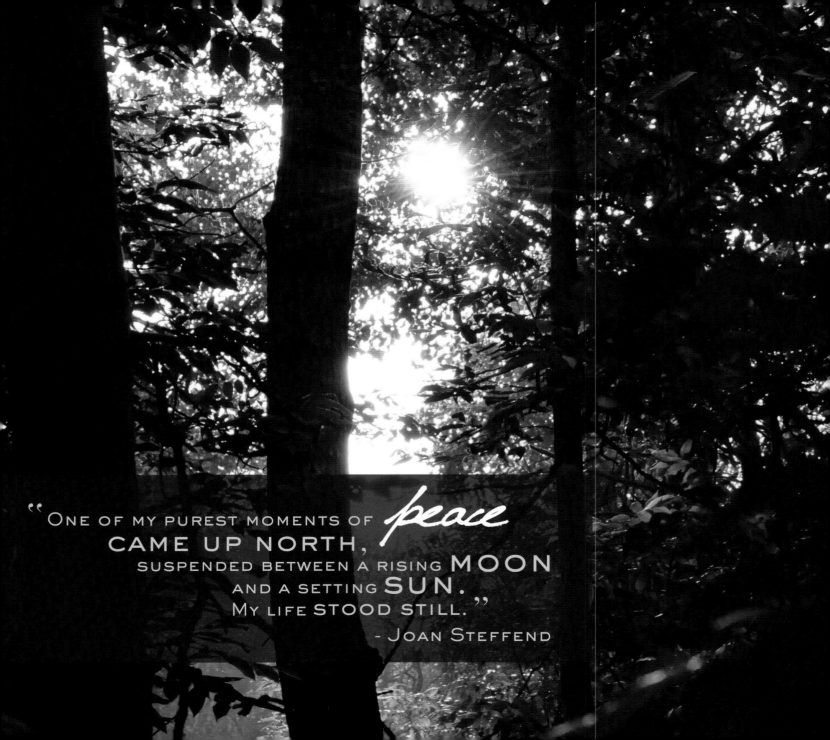

"ONE OF MY PUREST MOMENTS OF *peace* CAME UP NORTH, SUSPENDED BETWEEN A RISING MOON AND A SETTING SUN. MY LIFE STOOD STILL."

— JOAN STEFFEND

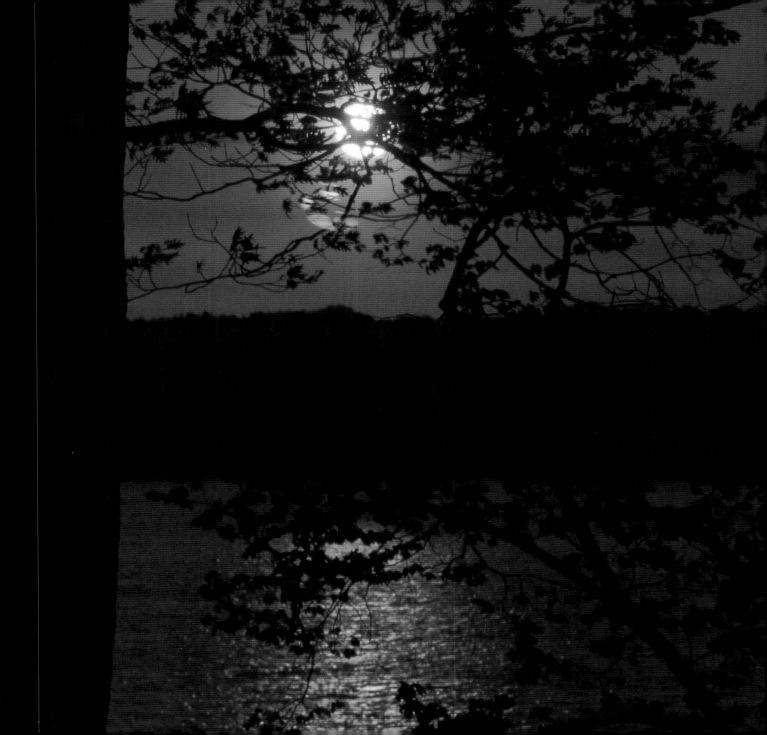

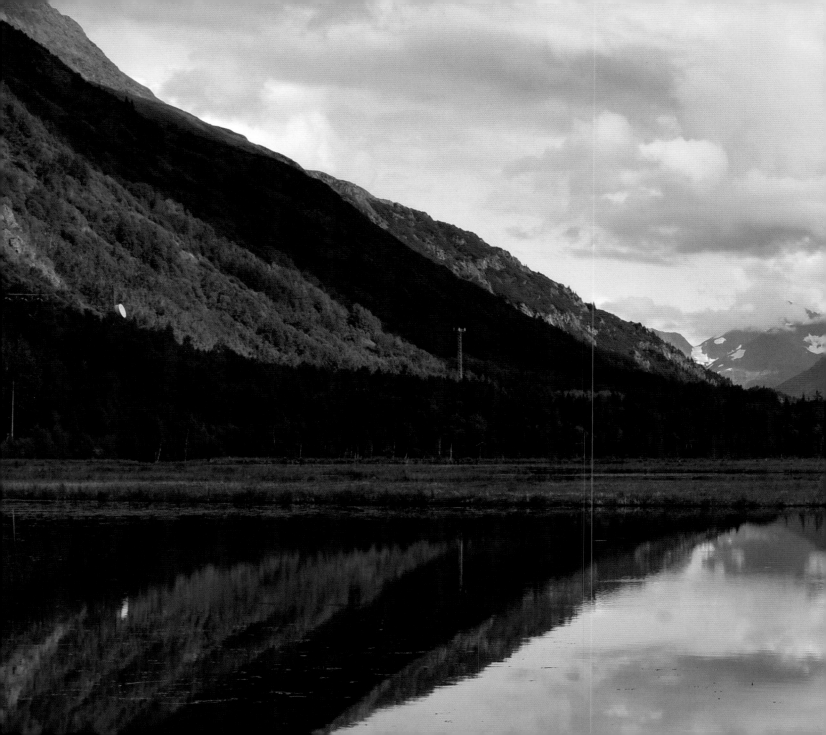

"*Heaven* IS UNDER OUR **FEET,**
AS WELL AS OVER OUR **HEADS.**"
- HENRY DAVID THOREAU

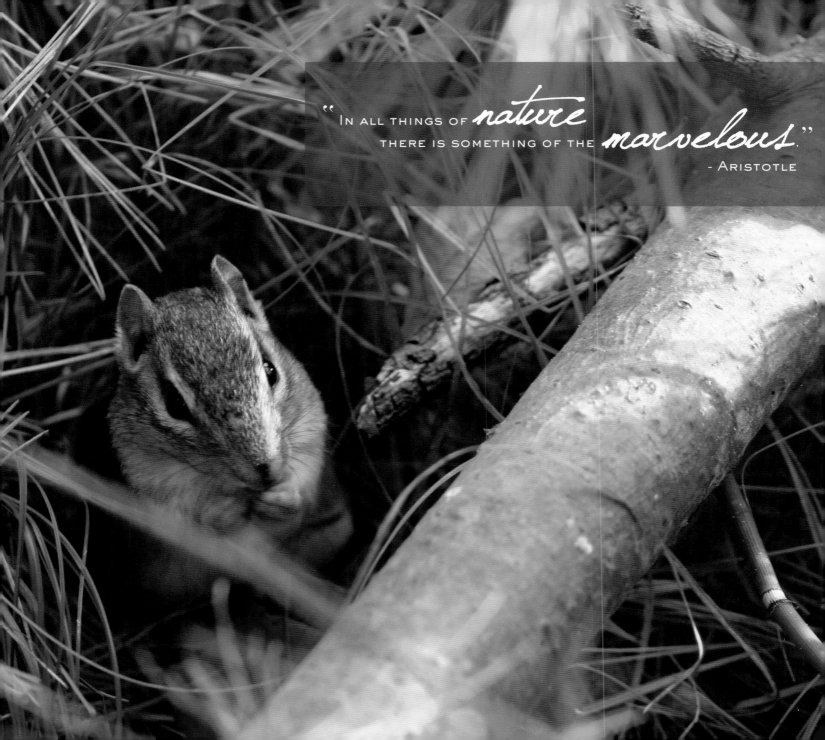

" IN ALL THINGS OF *nature*
THERE IS SOMETHING OF THE *marvelous*."
- ARISTOTLE